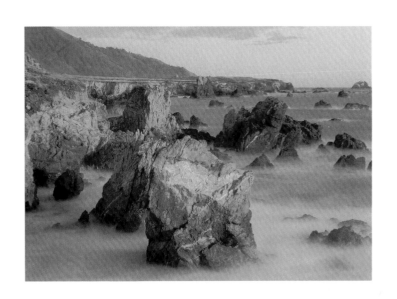

CALIFORNIA

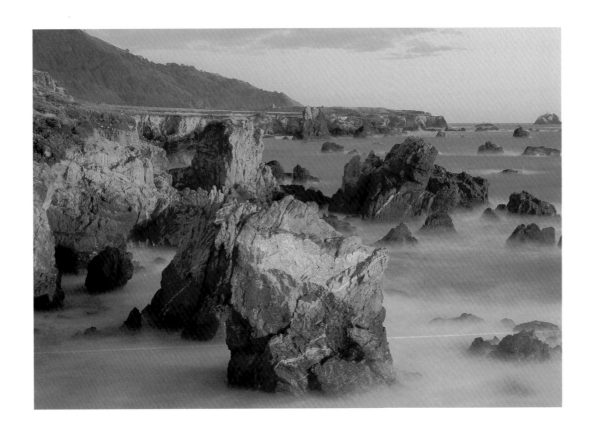

WHITECAP BOOKS

Text by Tanya Lloyd
Edited by Elaine Jones
Photo editing by Tanya Lloyd
Proofread by Lisa Collins
Cover and interior design by Steve Penner
Desktop publishing by Susan Greenshields
Printed and bound in Canada

National Library of Canada Cataloguing in Publication Data

Lloyd, Tanya, 1973–

 California

 ISBN 1-55285-028-5

 1. California—Pictorial works. I. Title.
F862.L56 2000 979.4'054'0222 C00-910061-X

The publisher acknowledges the support of the Canada Council and the Cultural
Services Branch of the Government of British Columbia in making this publication
possible. We acknowledge the financial support of the Government of Canada through
the Book Publishing Industry Development Program for our publishing activities.

**For more information on the America Series and other Whitecap Books
titles, please visit our web site at www.whitecap.ca.**

The tallest trees, the oldest buildings, the most spectacular sights and unique landscapes—California is a collection of superlatives. From the amusements of Disneyland to the golf courses of Palm Springs, the state offers every imaginable attraction. From the giant trees in Sequoia National Park to the below-sea-level mud flats in Death Valley, the slopes of Mount Shasta and the cliffs of Laguna Beach, it boasts unequaled sights and unparalleled scenery. Which explains why more people visit California than any other state in America. Almost 300 million trips are taken here each year, generating $60 billion for the economy and creating 700,000 jobs.

The first "tourists" to reach the shores of California were the explorers. Historians estimate that about 250,000 native people lived in the region when Hernando Cortés sailed parts of the coastline in 1535. He was followed by Portuguese and English sailors, including Sir Francis Drake, who is believed to have landed at Point Reyes, and may have been the first European to come ashore. The explorers sailed home with stories of sun and gold—stories not proven until centuries later.

In January 1848, James Marshall was working on the construction of a sawmill when he found small nuggets of metal in the American River. The nuggets proved to be gold, and when news of the discovery spread, half a million people thronged to the state. Within four years, annual gold production reached $81 million. Many of the fortune seekers left California when gold was discovered on the Fraser River in British Columbia, but prospecting continued until about 1864, leaving a legacy of ghost towns and historic sites.

The riches in the Golden State today are found in the shops of Rodeo Drive, the commerce of San Francisco, the mansions of Monterey Bay, and the glamor of Hollywood. Television and film have sent images of never-ending white sand beaches and waving palm trees around the world, tempting visitors to this ocean paradise. Yet despite the booming population of Los Angeles and the constant influx of tourists, California retains vast tracts of pristine forest and desert. There are more than 260 state parks, 23 national parks, and 18 national forests. In these untouched places, it's possible to imagine California as the explorers saw it centuries ago.

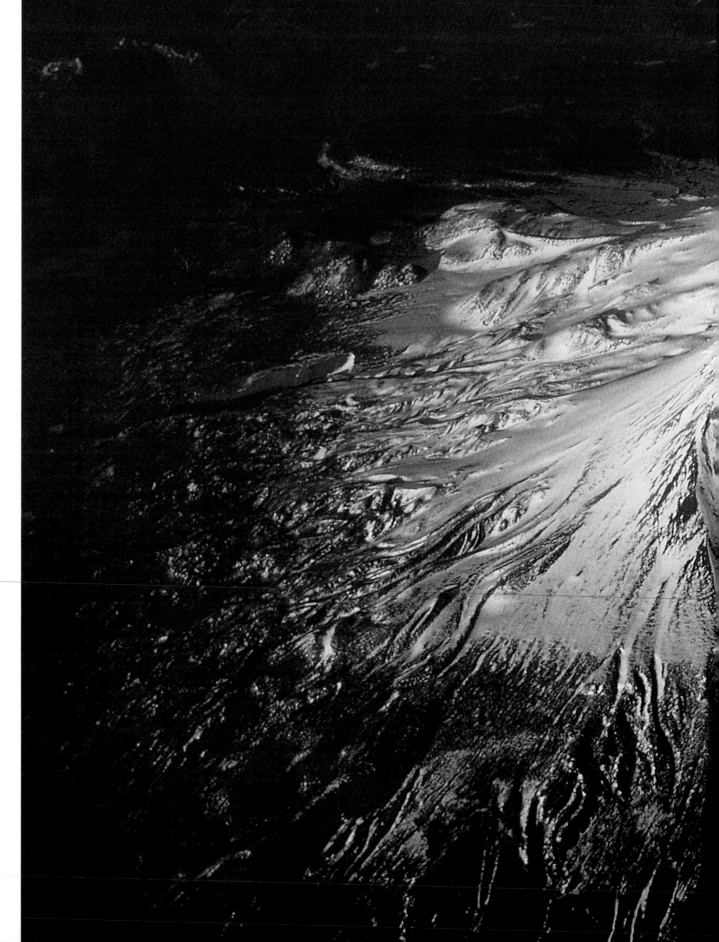

Eight glaciers cap Mount Shasta, one of California's most stunning peaks. Reaching 14,161 feet high, the mountain's challenging slopes attract mountaineers from around the world.

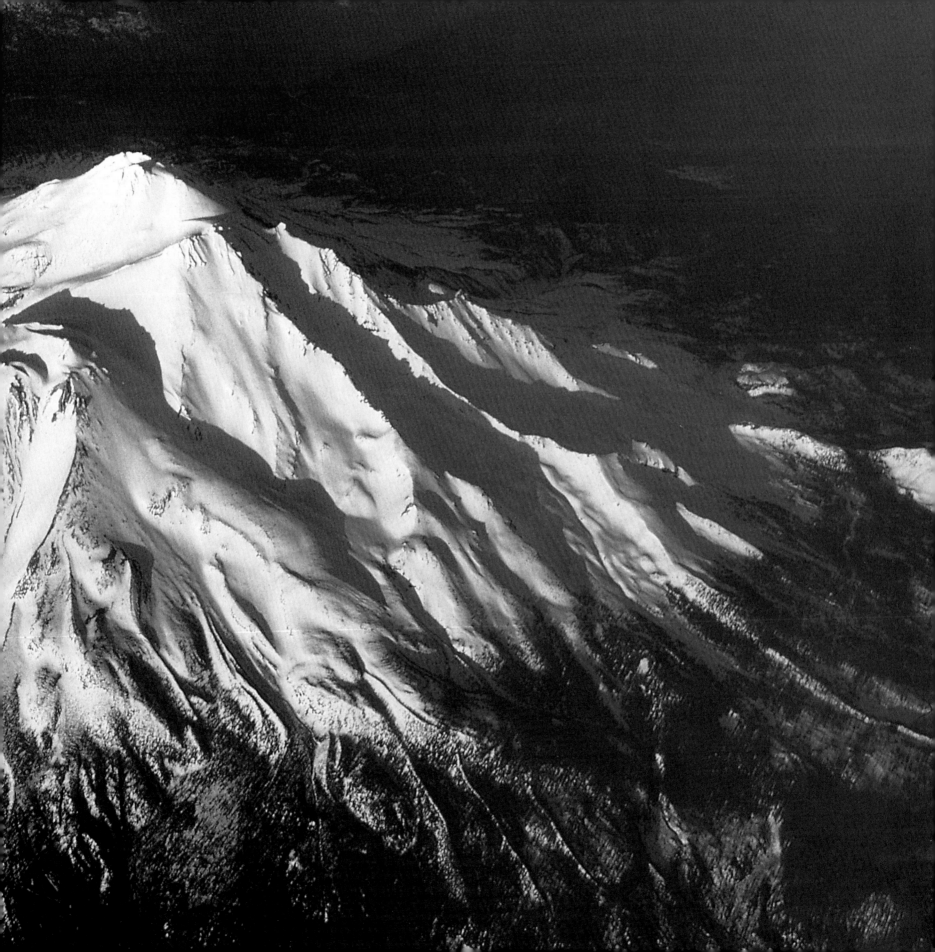

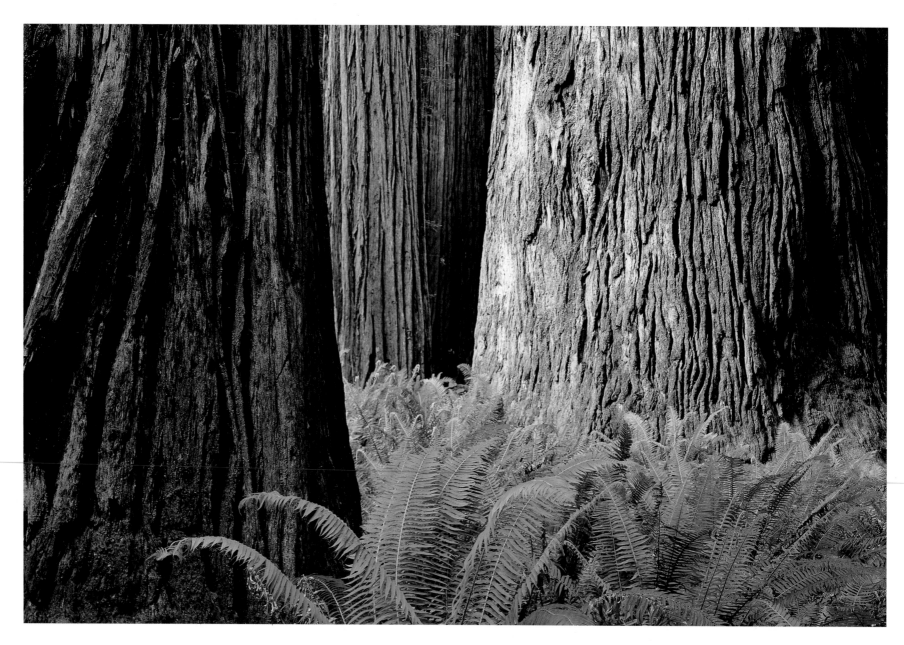

Some of the tallest trees in the world are protected by four California parks—Redwood National Park, and Jedediah Smith, Del Norte Coast, and Prairie Creek Redwoods state parks. Together, these preserves form a UNESCO World Heritage Site and Biosphere Reserve.

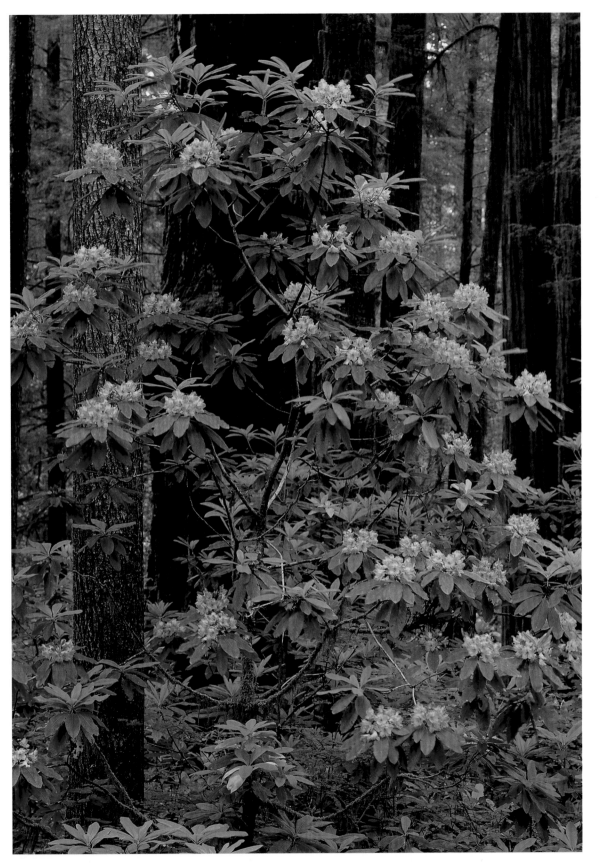

Jedediah Smith Redwoods State Park is named after a trapper and mountain man who in the early 1800s was the first European to explore northern California's interior. About 100 years after Smith's arrival, the park was established to protect 10,000 acres of old-growth redwoods.

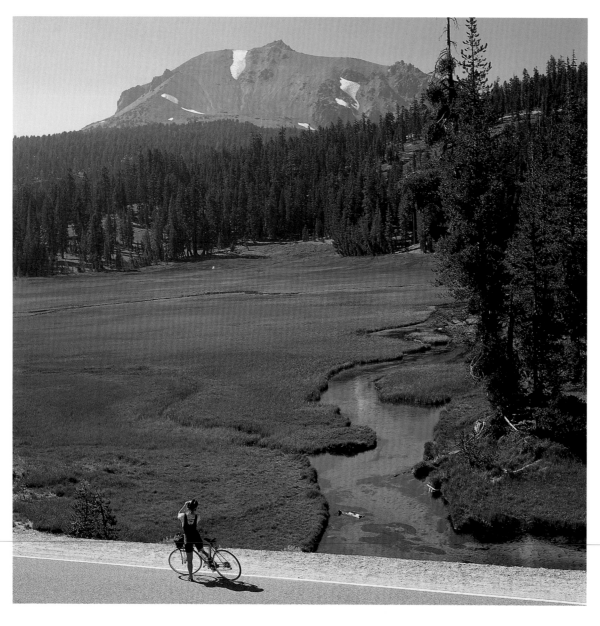

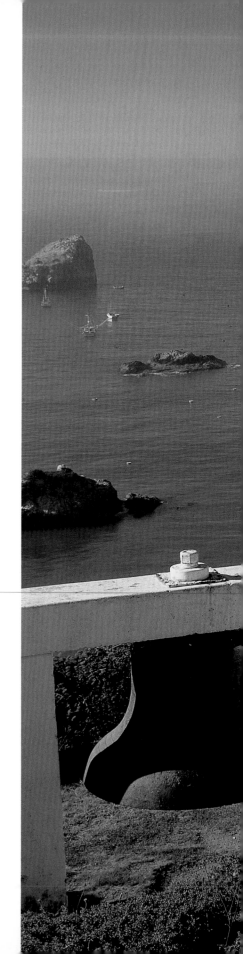

The 106,000 acres of Lassen Volcanic National Park encompass several types of volcanic mountains. One of these, Lassen Peak, erupted in 1914 and continued to show signs of volcanic activity until 1921.

A picturesque replica of the original 1871 light-house overlooks the Trinidad harbor. Once an important supply town and port, Trinidad is now a favorite tourism destination.

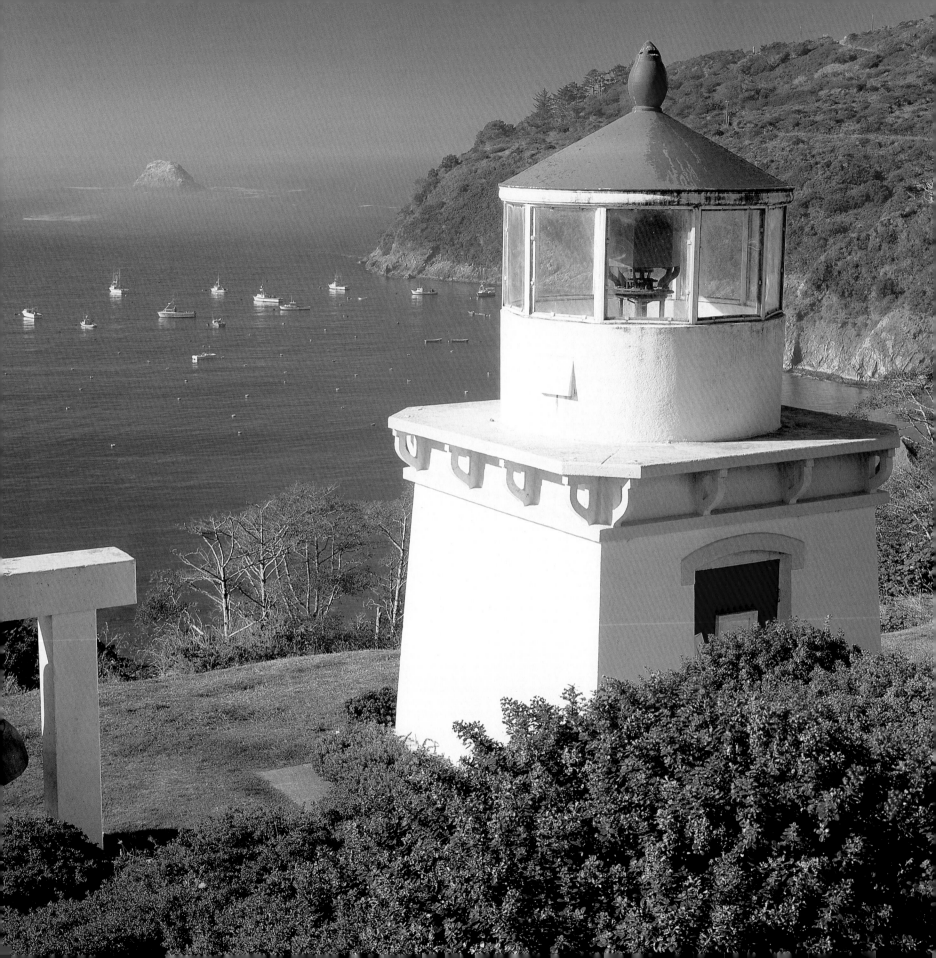

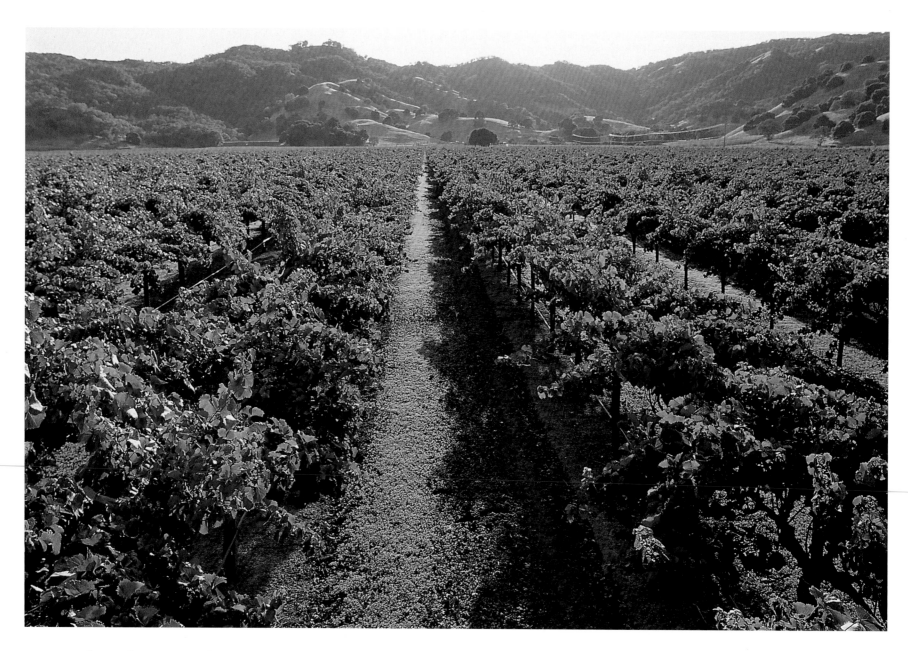

Vineyards and wineries have graced the Napa Valley since the mid-1800s, taking advantage of the warm temperatures and long growing season.

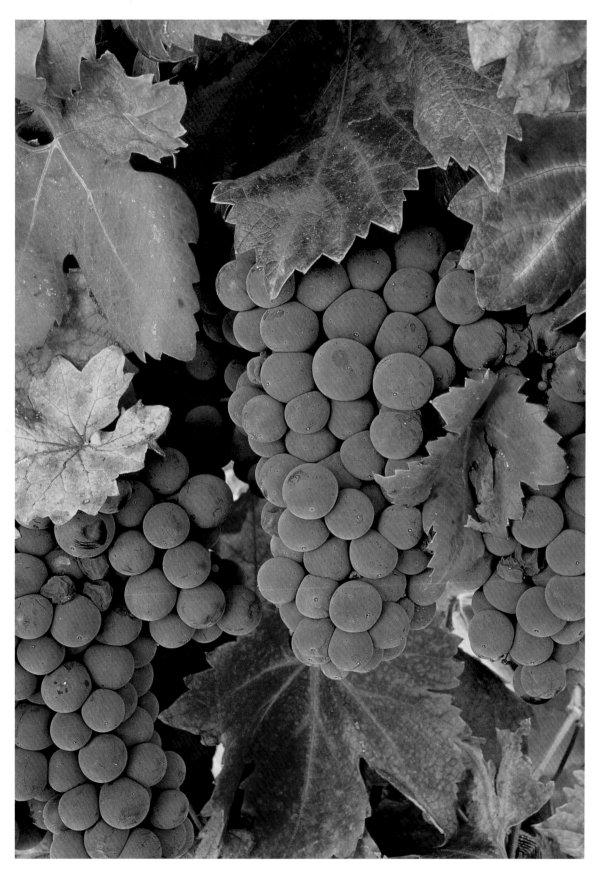

About 35,000 acres of the 297,000-acre Napa Valley have grapevines planted on it. The name *Napa* means "land of plenty" in the language of the Wappo peoples who first inhabited this area.

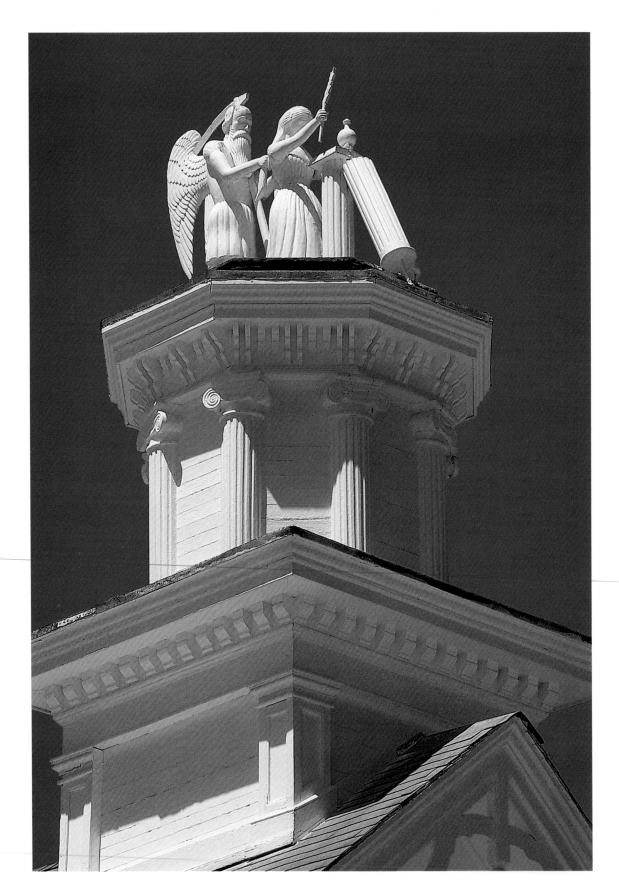

The first European in Mendocino was William Kasten, the survivor of an 1850 shipwreck off the coast. He was soon joined by merchants, mill owners, and loggers. Many of the buildings in Mendocino's historic district date from the time of those early settlers.

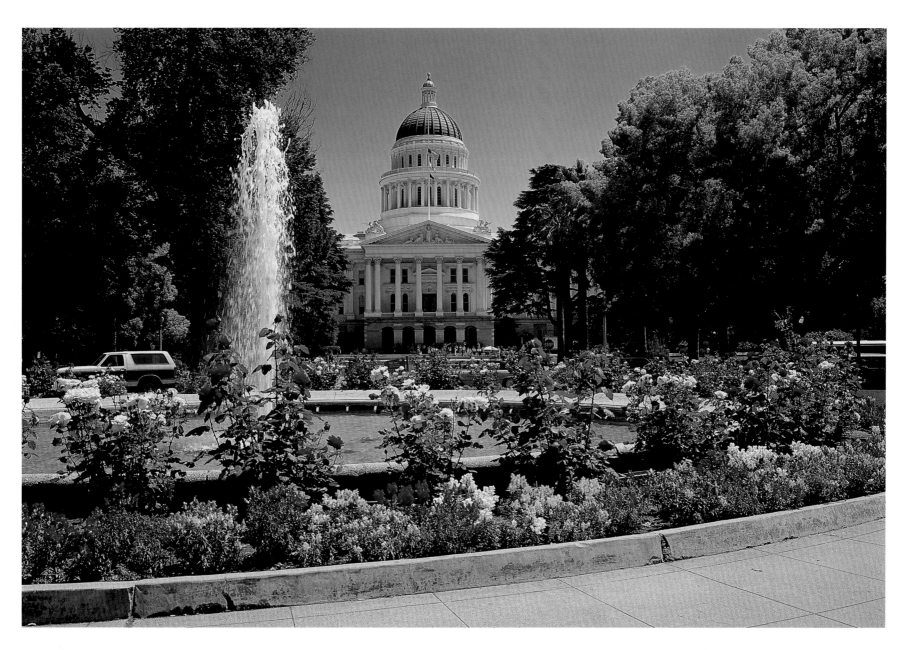

Sacramento boomed in the early 1850s, when thousands arrived to seek their fortunes in gold on the American River. The capitol building was completed in 1874 and a 1980s restoration project has revived the building's turn-of-the-century grandeur.

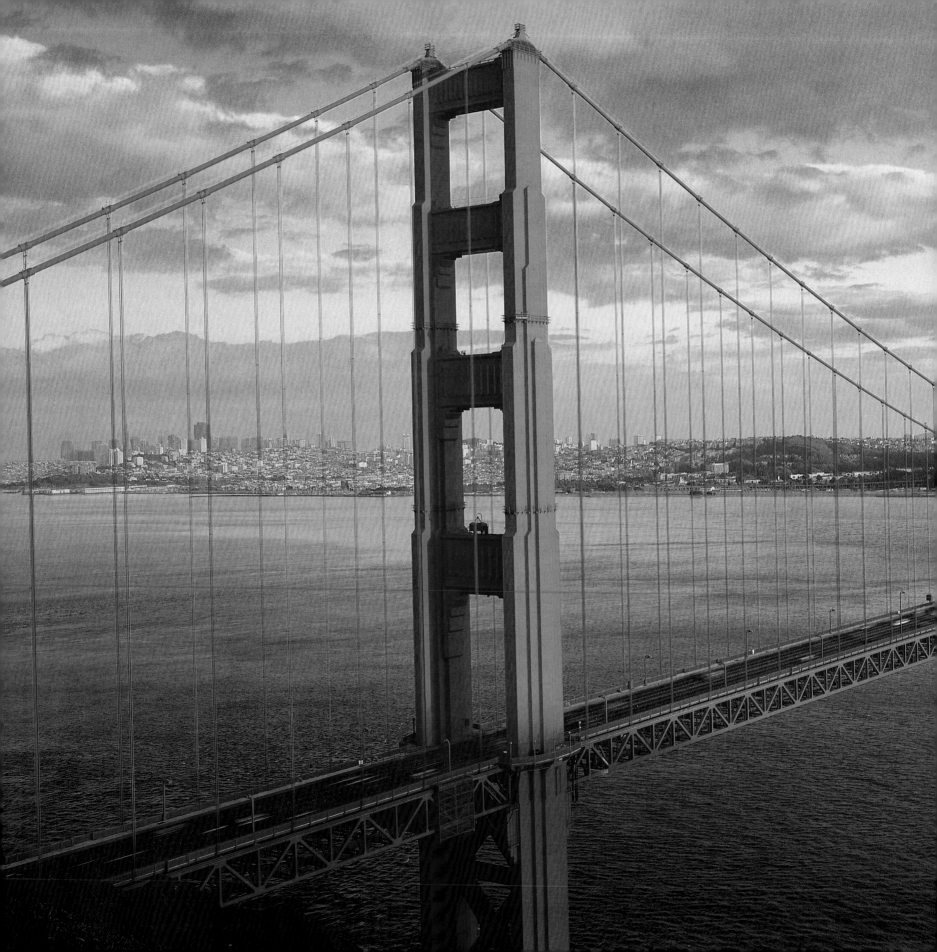

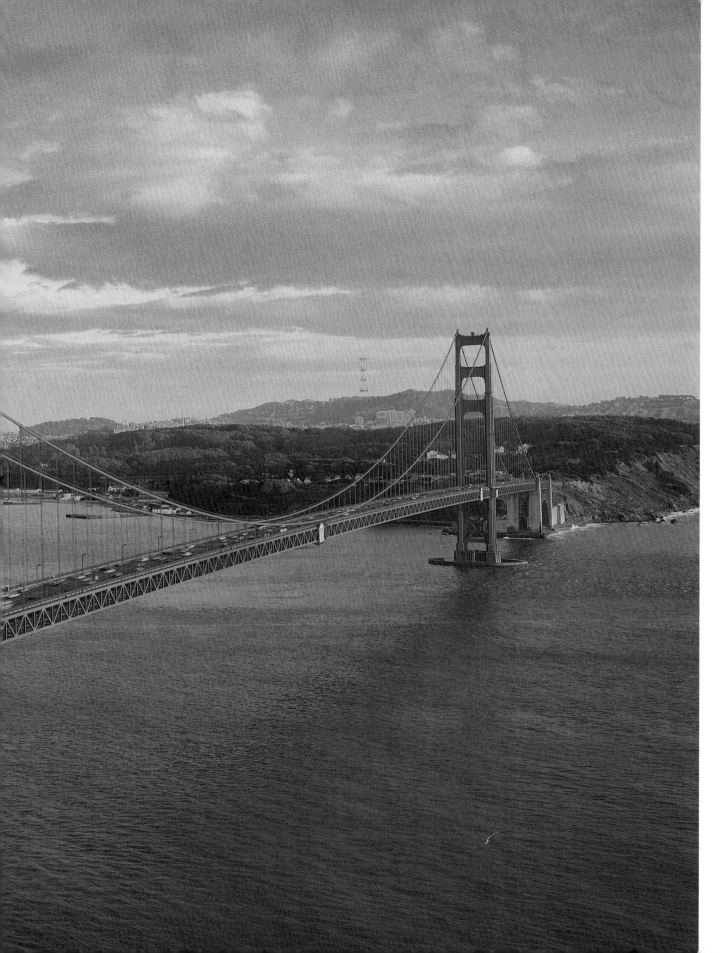

One of the world's longest suspension bridges, extending for about nine-tenths of a mile, San Francisco's Golden Gate Bridge hangs 220 feet above the water, reaches 746 feet high, and boasts cables that can support 200 million pounds.

San Francisco's Chinatown is the largest in the world. Chinese immigrants first arrived in California to work in the gold rush and on the railway. Today, there are about 150,000 people of Chinese descent in San Francisco alone.

Domingo Ghirardelli, an Italian-born merchant and chocolatier, built this attractive complex as the base of his expanding business. He retired in 1892, and his complex has since become a popular shopping destination.

18

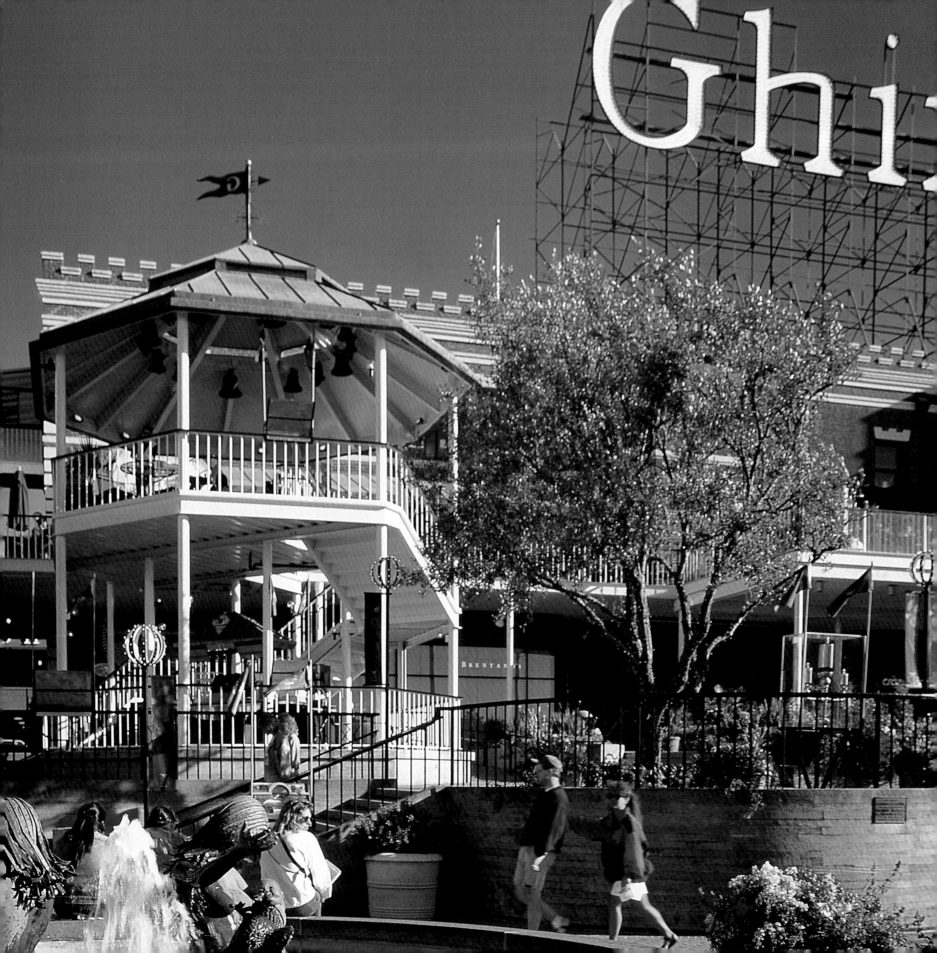

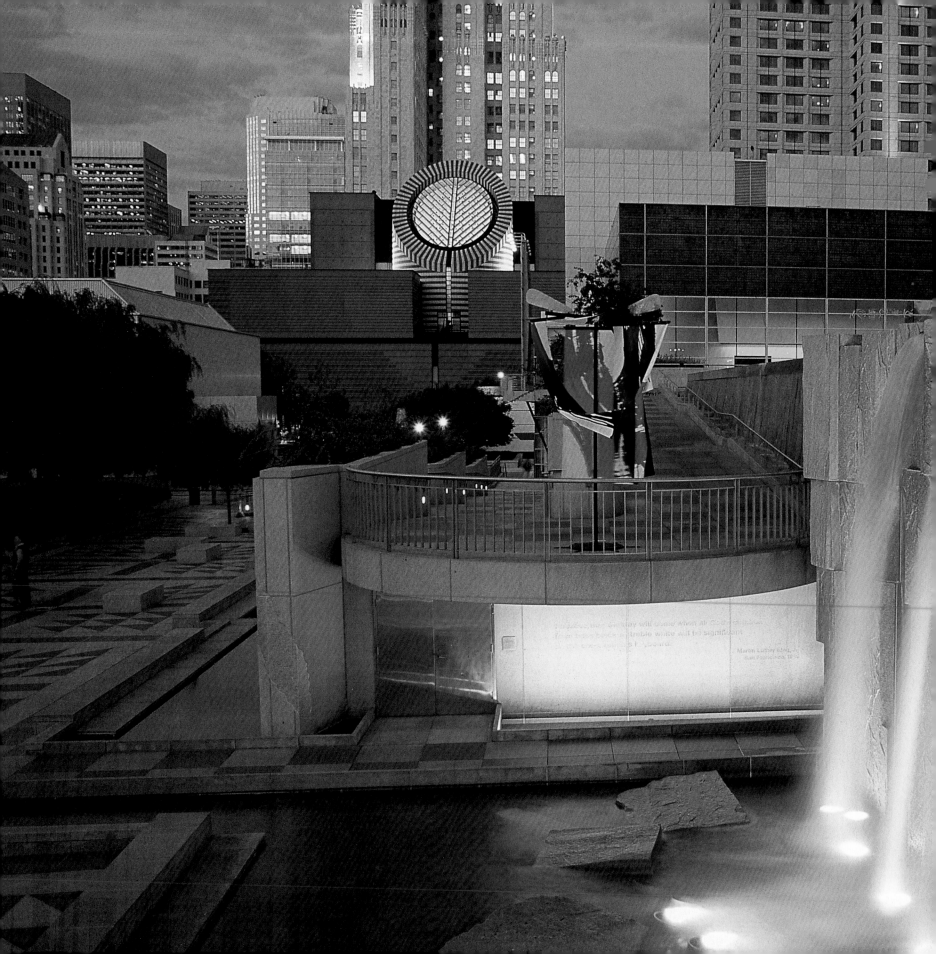

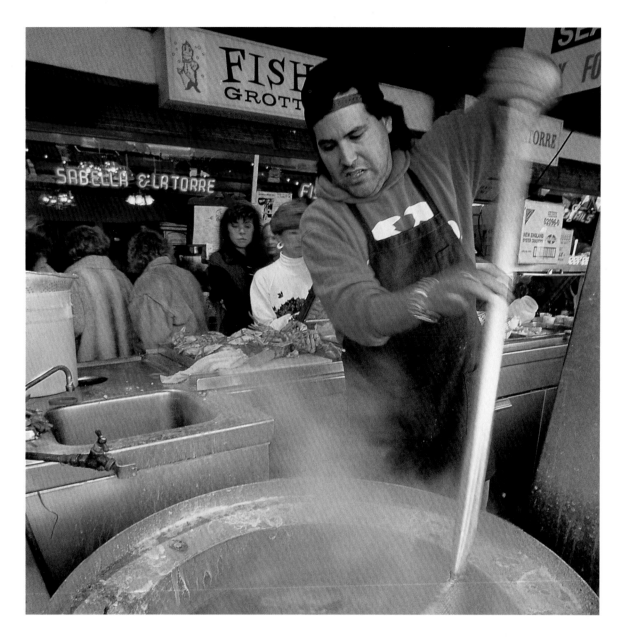

At Fisherman's Wharf, visitors can sample clam chowder in sourdough soup bowls or fresh Dungeness crab. A century ago, a fishing fleet moored here each evening.

Yerba Buena Gardens includes a rooftop playground, a bowling center, a children's garden, and a skating rink, all balanced above the Moscone Center, San Francisco's primary convention venue. The complex is one of the attractions of SoMa, the district south of Market Street—one of the city's entertainment and nightlife hot spots.

21

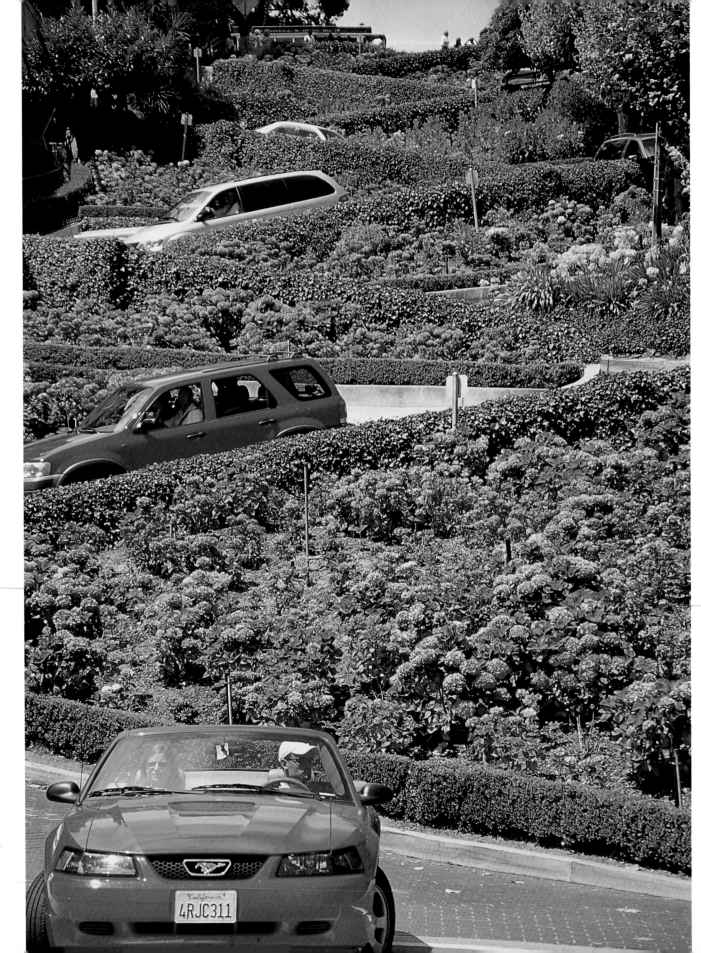

San Francisco is full of steep and twisted streets, but the most crooked—and the most famous—is Lombard Street. Eight switchbacks crisscross the manicured hillside.

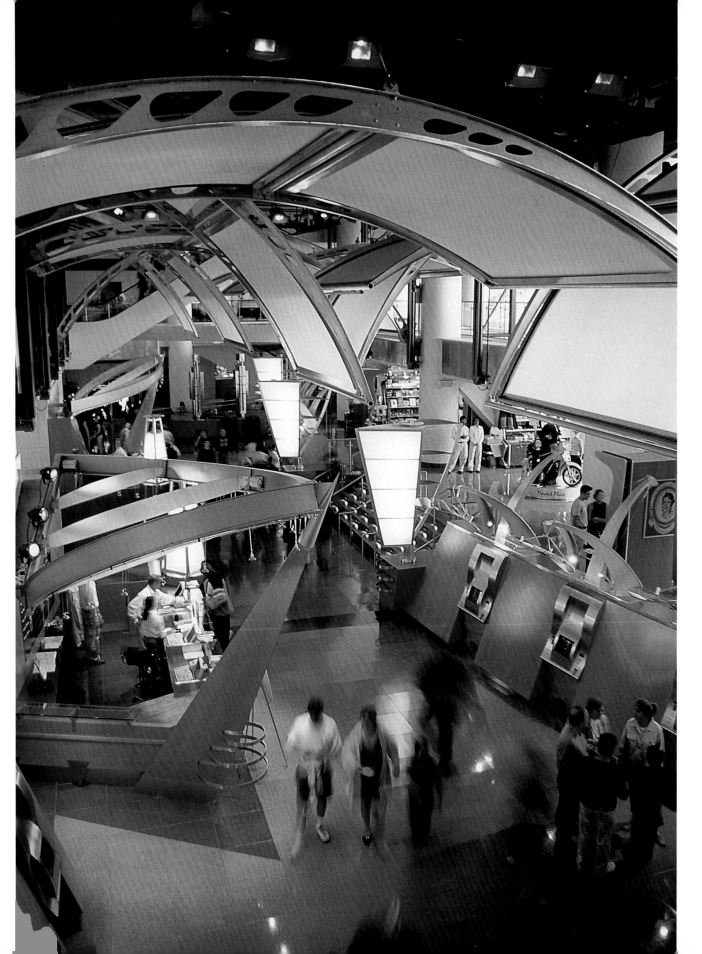

Metreon is an entertainment complex like no other, complete with the city's largest cinemas, a virtual reality arcade, and nine restaurants. The center encompasses 350,000 square feet. The atrium-style lobby alone is as long as a football field.

23

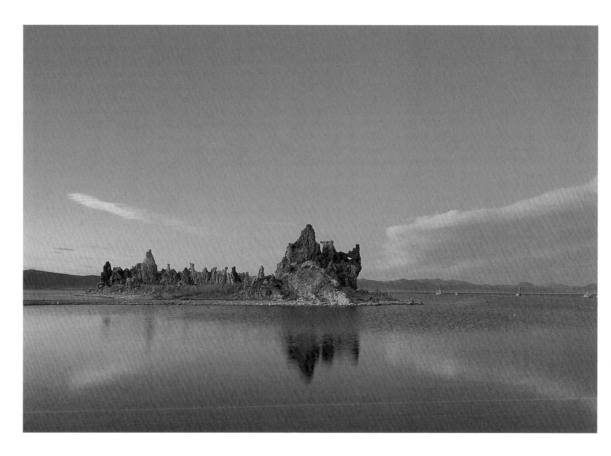

Mono Lake is two to three times more salty than the ocean. Streams and underground waterways bring in mineral-rich water, but the lake has no outlets. Water slowly evaporates, leaving the salt and minerals behind.

Copperopolis was founded in 1860, when prospectors William K. Reed, Dr. Allen Blatchly, and Thomas McCarty discovered copper at the site. By the mid-1900s, Copperopolis had produced about $12 million worth of copper.

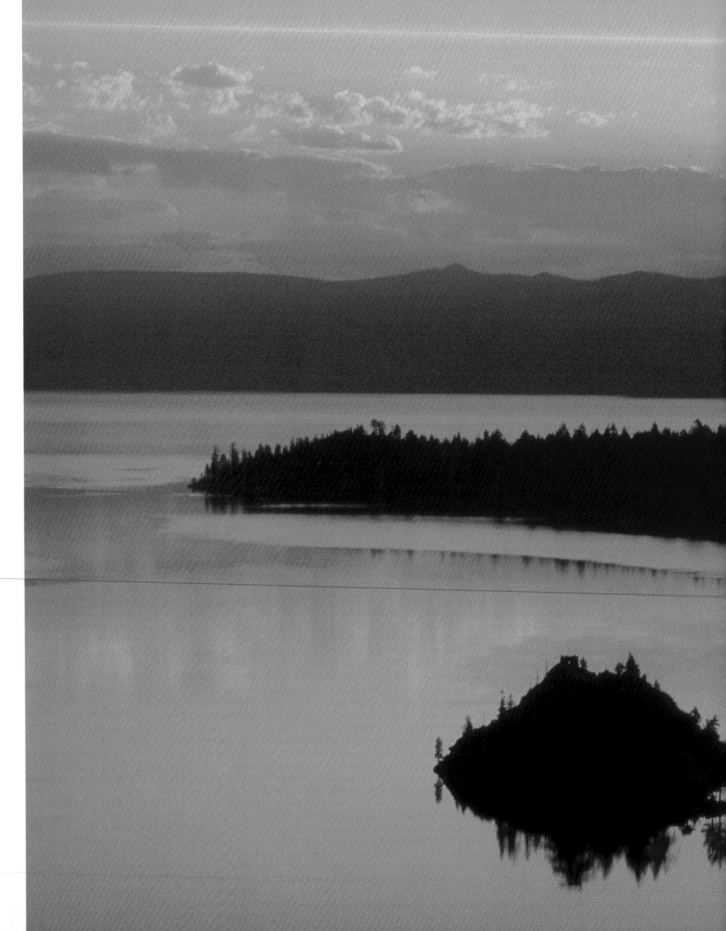

More than 100,000 visitors crowd the shores of Lake Tahoe in the summertime, yet the water remains amazingly pure and so clear that objects are visible at a depth of 75 feet. Development in the area is strictly controlled to maintain the pristine environment.

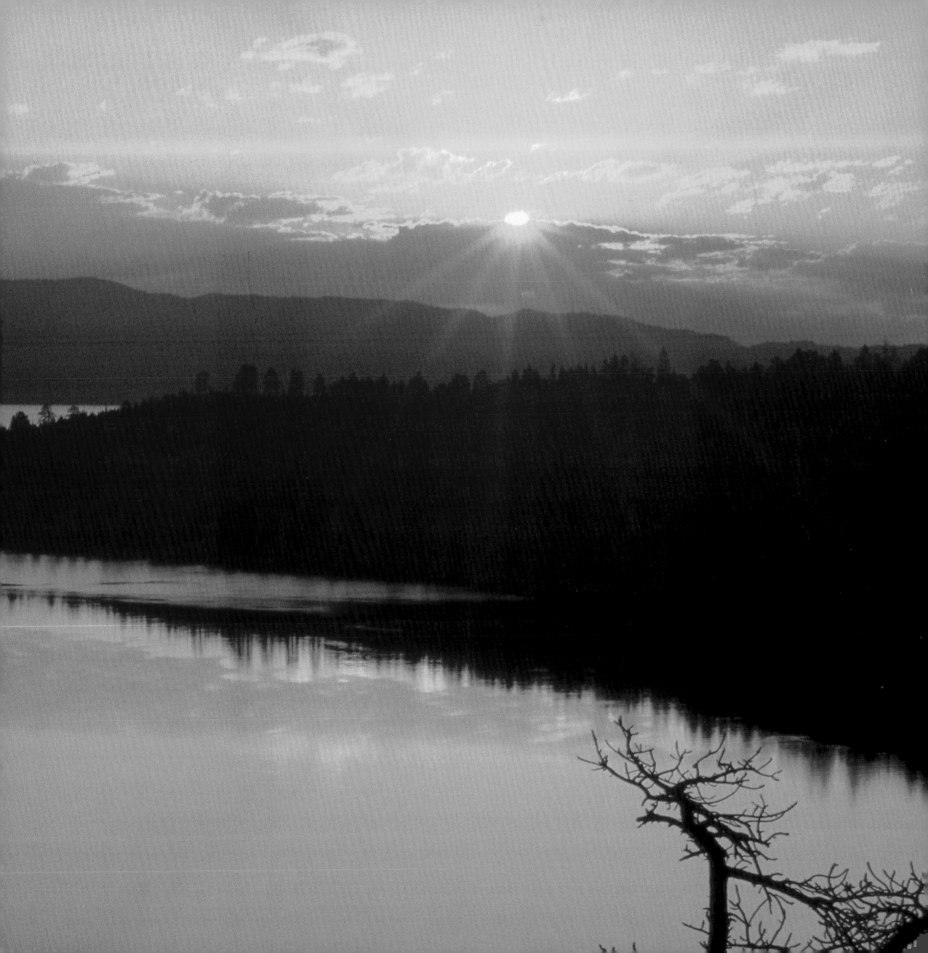

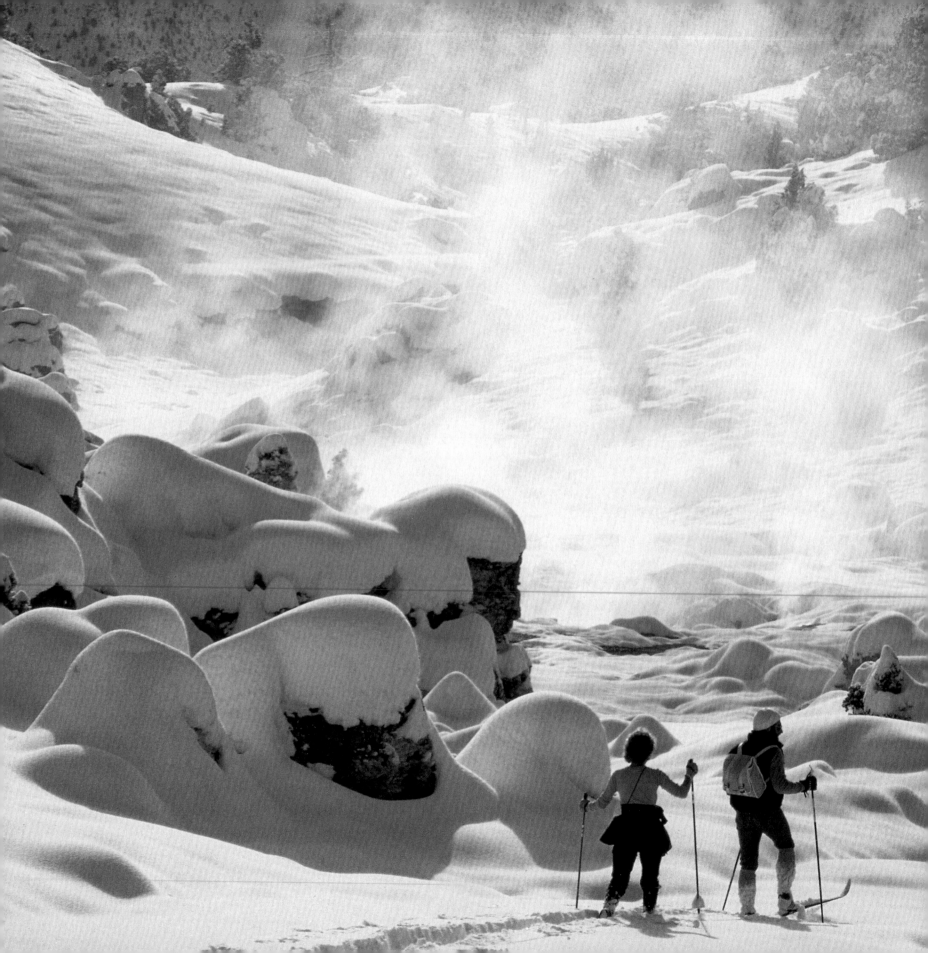

Cross-country skiers make their way through snowy wilderness in the Sierra Nevada Mountains. A trio of national parks protect some of the more spectacular parts of this range— Yosemite, Kings Canyon, and Sequoia.

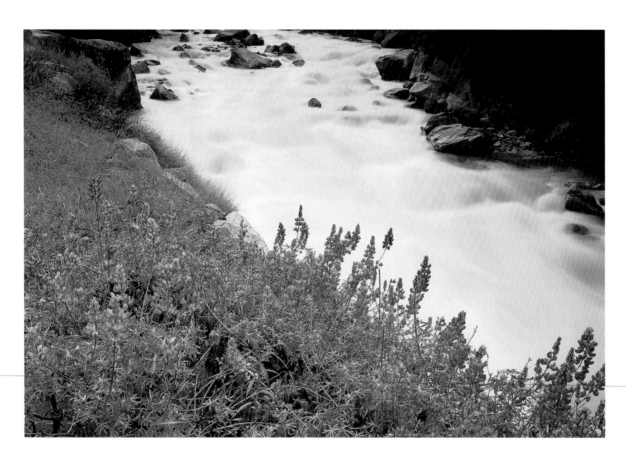

Lupines bloom along the banks of the Merced River in Yosemite National Park, an area Theodore Roosevelt called "the most beautiful place on Earth." About four million people tour the park's natural wonders each year.

Yosemite Falls, the hightest waterfall on the continent, drops a total of 2,425 feet in three stages. It is most spectacular in early summer when meltwater from the peaks swells the park's rivers.

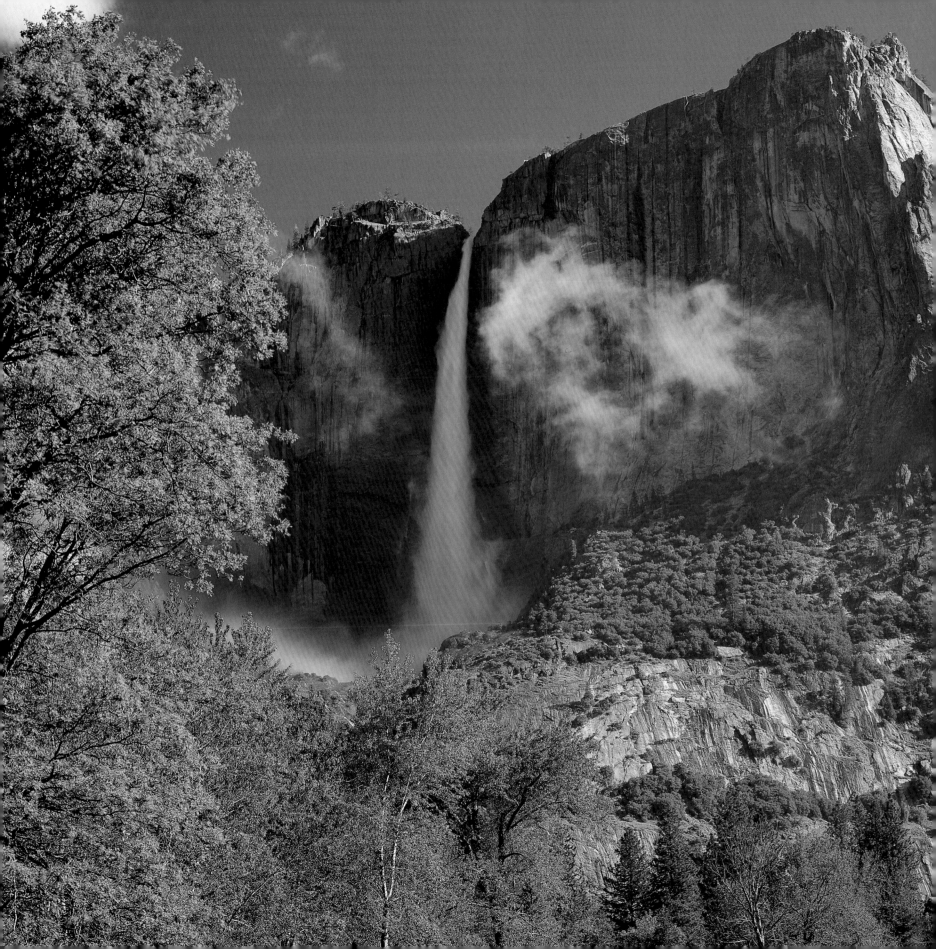

Built in 1903 by the Sierra Club, the LeConte Memorial Lodge was Yosemite's first public information center and is now a national historic landmark. It is named for former Sierra Club director and prominent geologist Joseph LeConte.

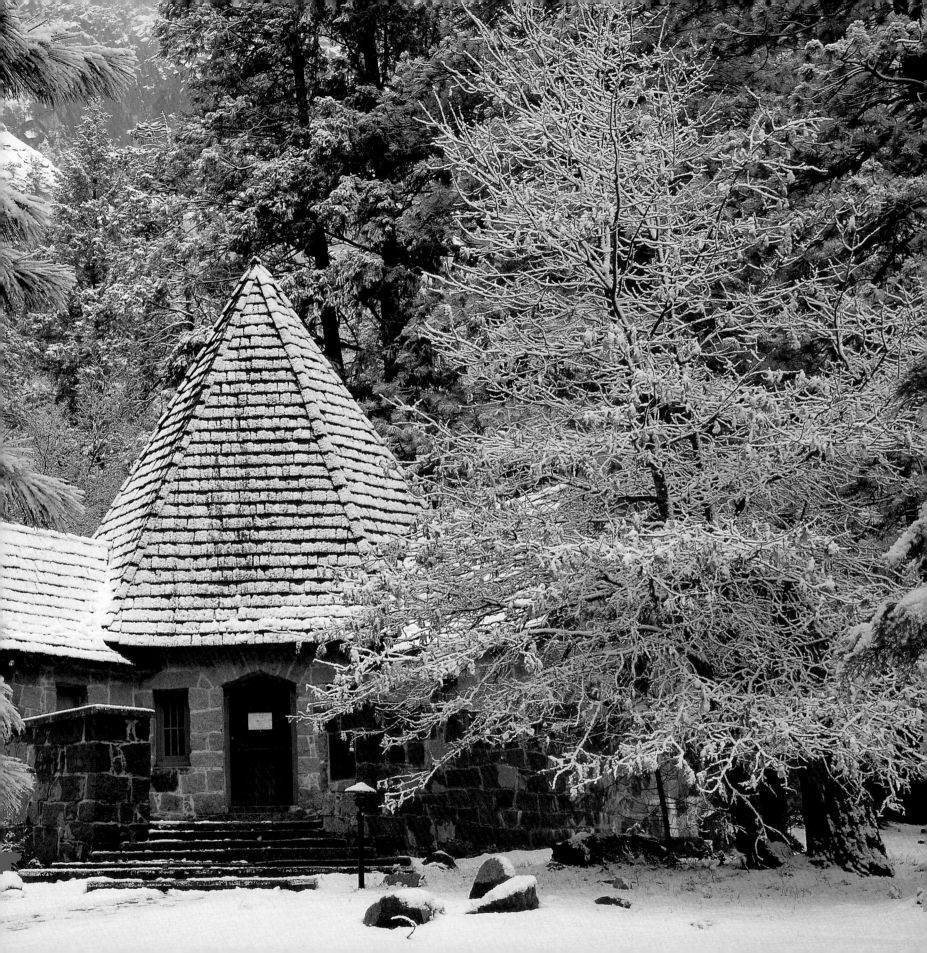

Spanish explorer Juan Rodriguez sailed the coastline of Monterey Bay in 1542 and claimed the area for Spain. During the next two centuries, he was followed by explorers, missionaries, military leaders, and merchants from around the world.

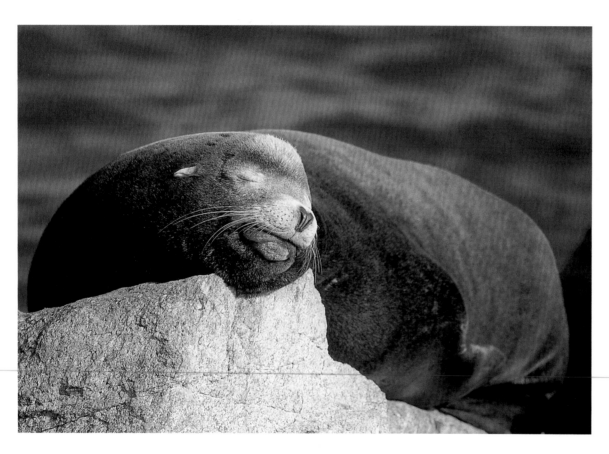

Thousands of California sea lions live along the coast, feeding on squid, octopus, herring, rockfish, smelt, hake, and lampreys. The distinctive "bark" of these gregarious animals can often be heard in the state's harbors.

There are 300,000 plants and animals at the Monterey Bay Aquarium. The facility has been teaching visitors about the Pacific since it opened in 1984.

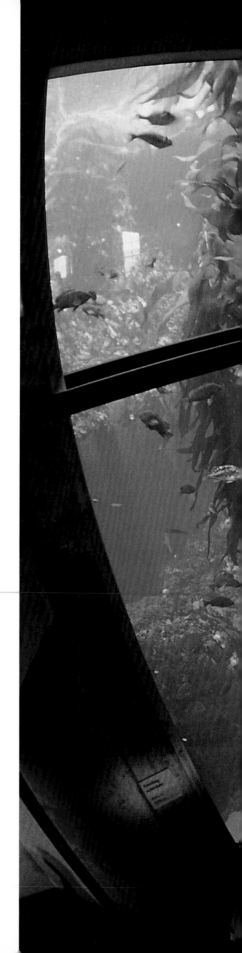

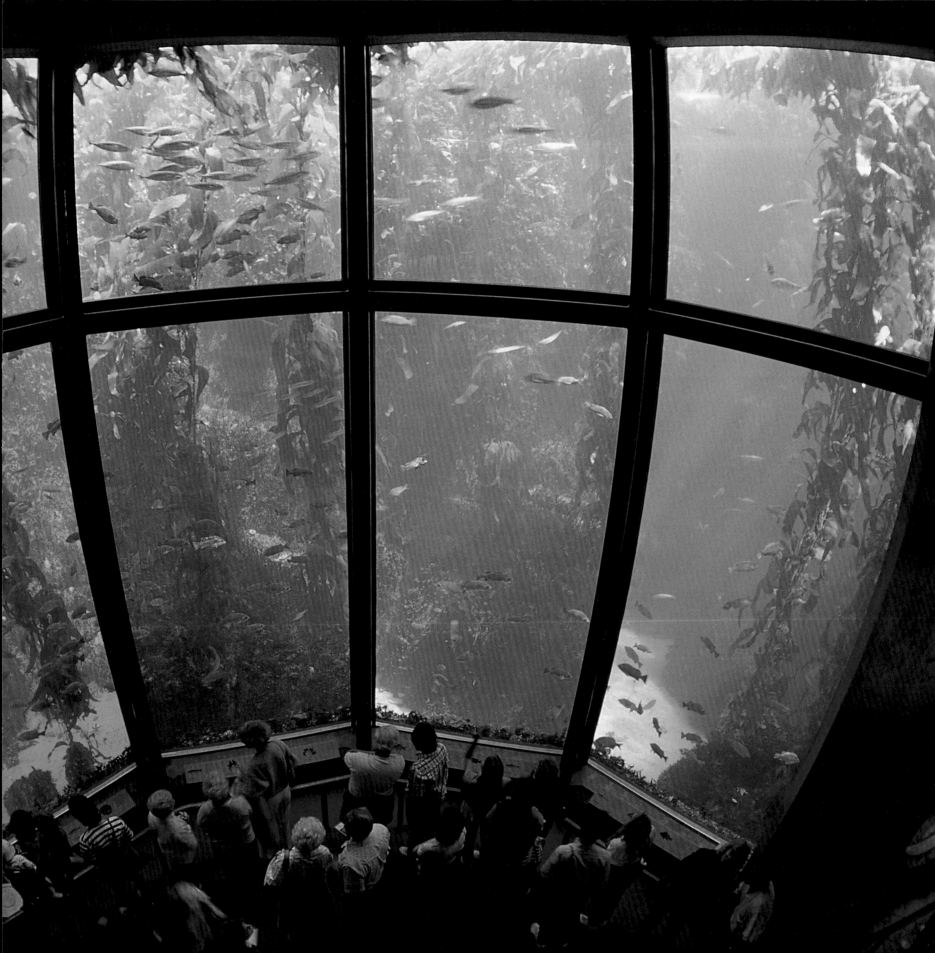

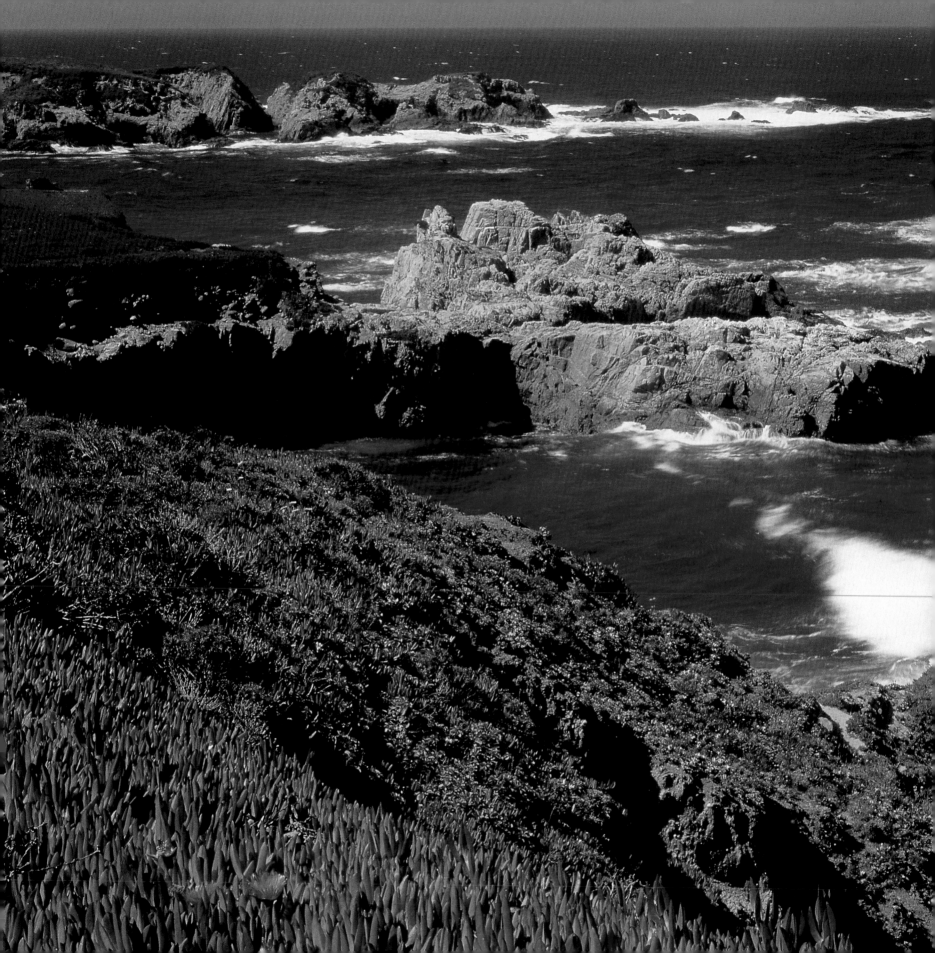

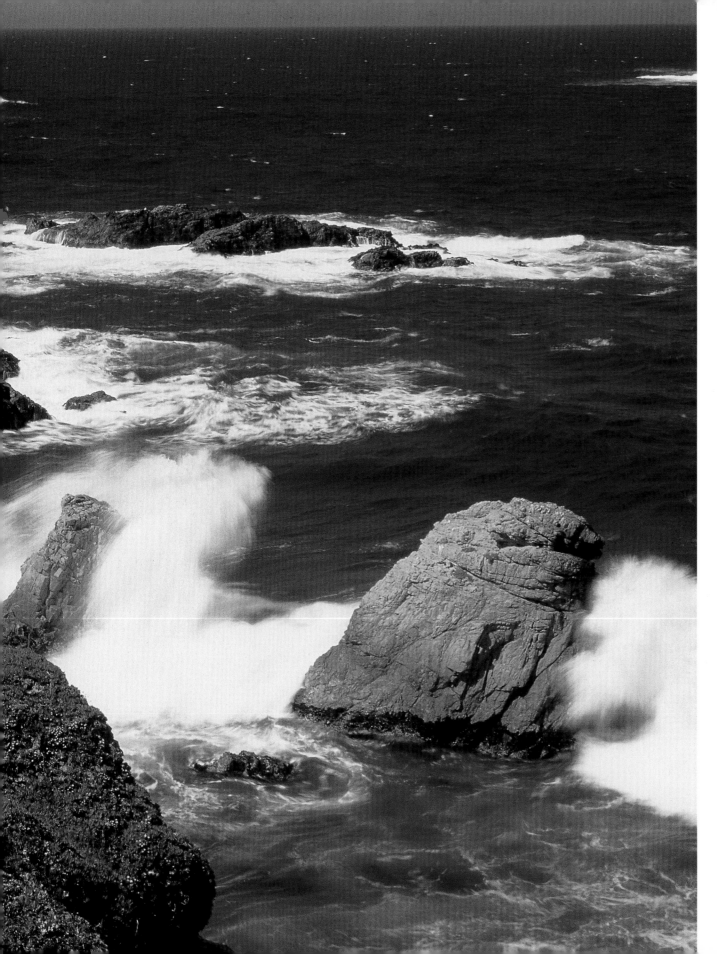

Home to sea lions, seals, otters, and an array of small mammals, Garrapata State Park combines two miles of waterfront vistas with lushly forested hiking trails. The park extends for 2,879 acres and draws almost 80,000 visitors each year.

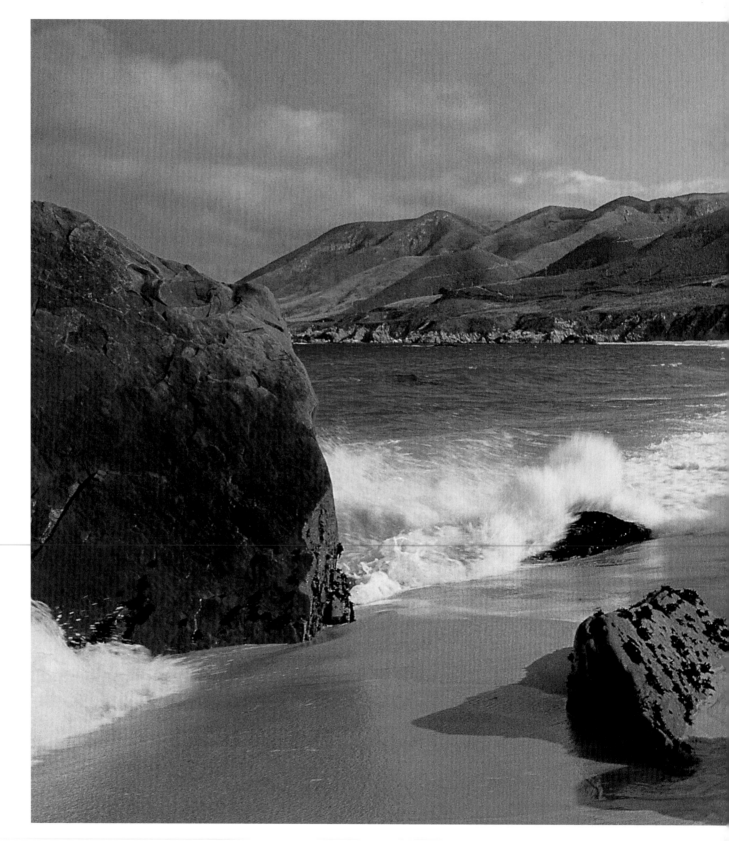

Route 1 winds its way along the headlands of Big Sur, creating a ribbon of civilization between the wilderness of the Santa Lucia Mountains and the rugged cliffs of the coastline and affording magnificent ocean views.

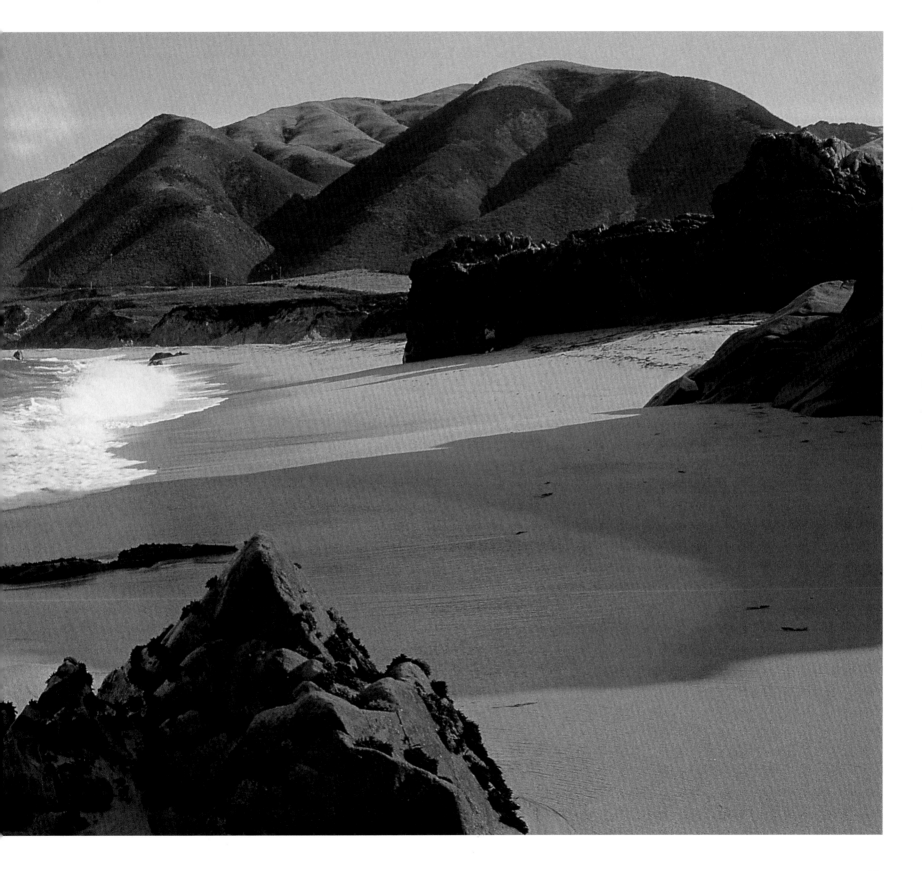

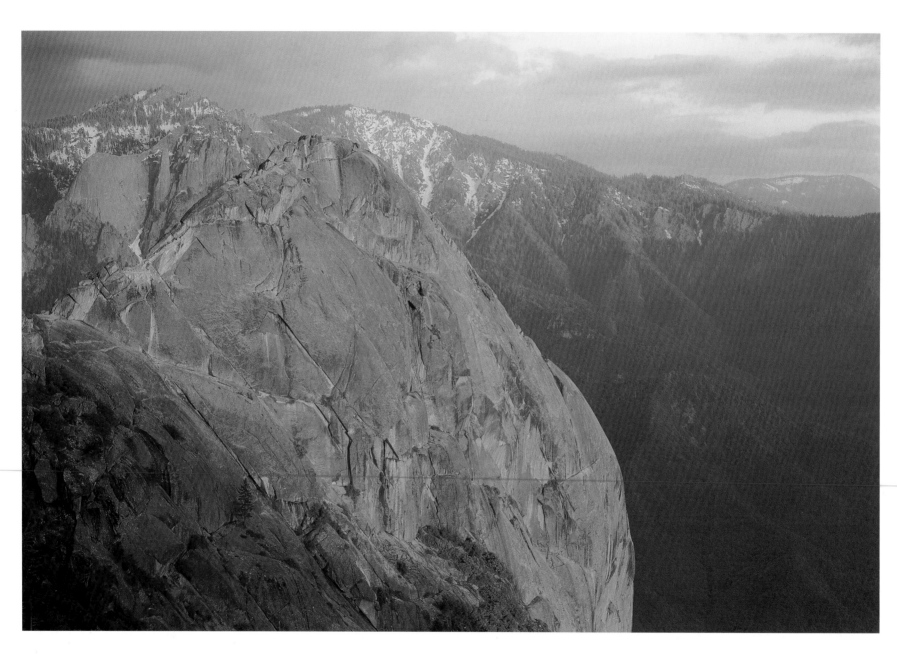

The Sierra Nevada mountain range, protected in part by Sequoia National Park, is larger than the French, Swiss, and Italian Alps combined. Some peaks reach more than 14,000 feet high.

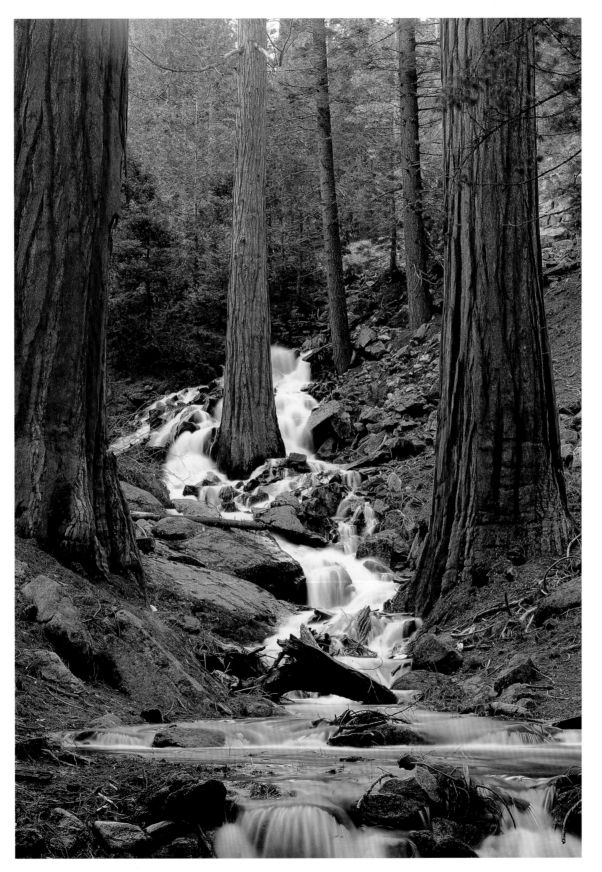

Indigenous only to the west slope of the Sierra Nevada Mountains, giant sequoias are the largest living things on Earth. In Sequoia National Park, the oldest trees have existed for more than 2,000 years and have branches more than 6 feet in diameter.

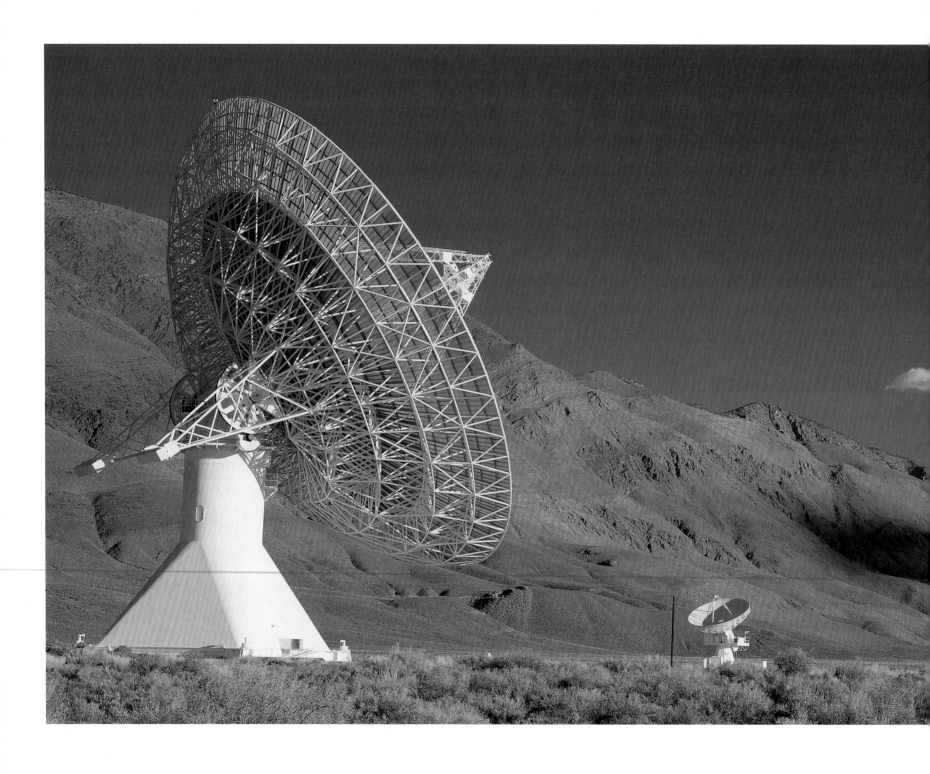

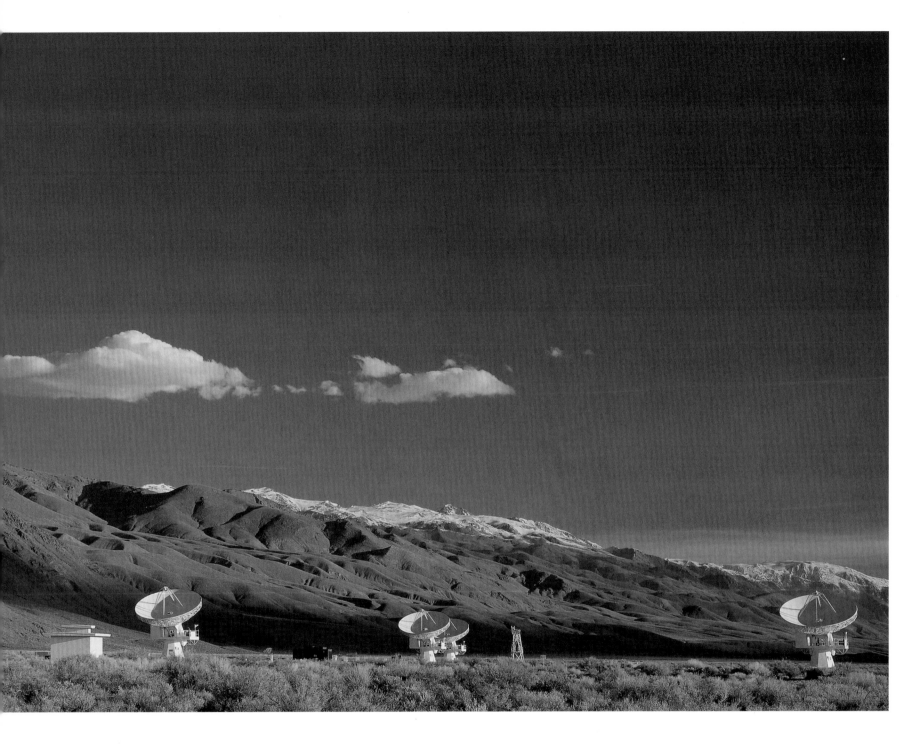

The Caltech Astronomy Department oversees the Owens Valley Radio Observatory, the world's largest university-operated radio observatory.

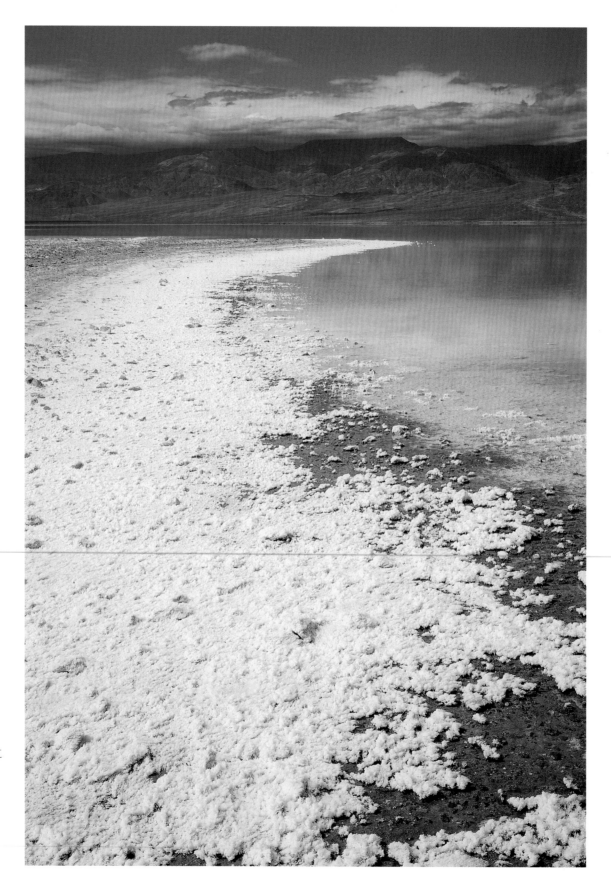

The salt flats at Badwater in Death Valley National Park are up to 282 feet below sea level—the lowest point on the continent. They extend for 200 square miles.

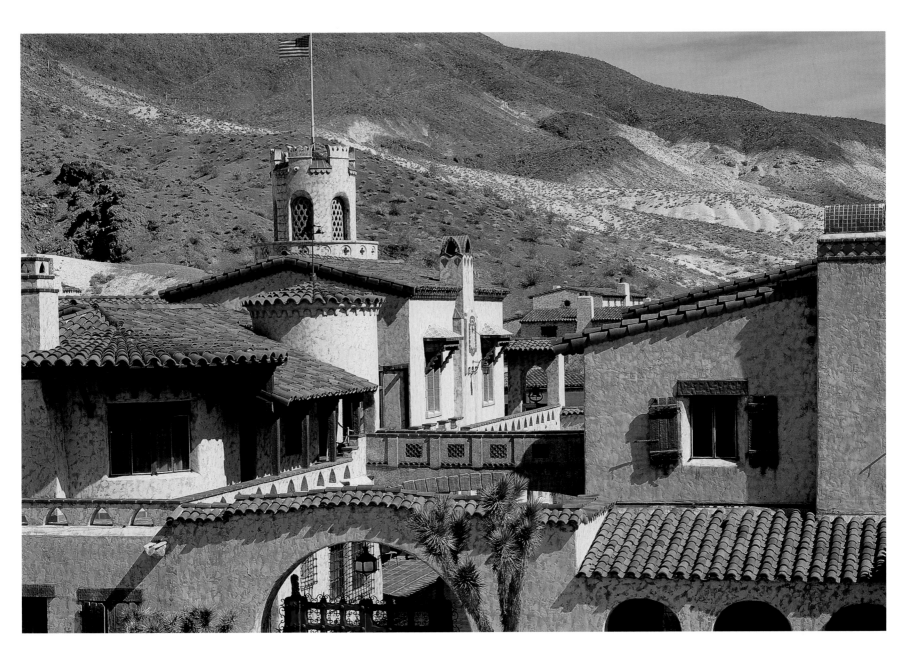

Scotty's Castle was built in the 1920s by Walter Scott, once a performer in Buffalo Bill's Wild West Show. The $2-million mansion was financed by Chicago millionaire Albert Johnson, who had been advised by his doctors to move to a warmer climate.

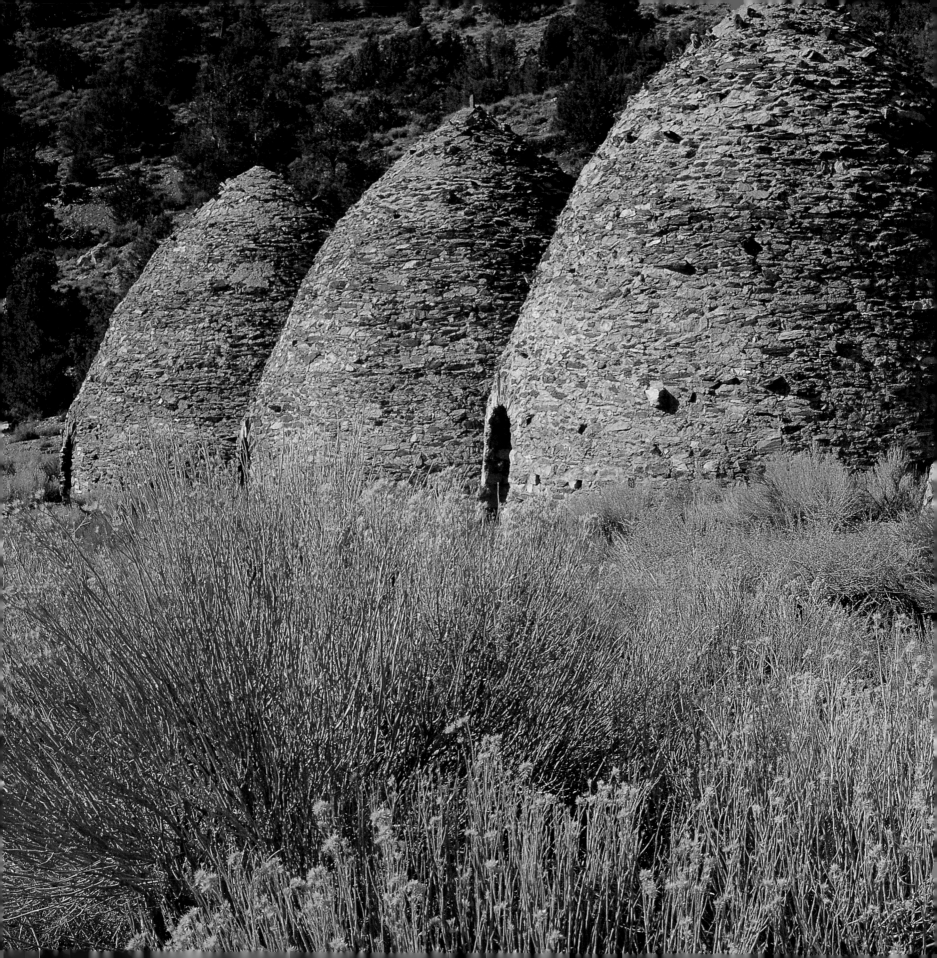

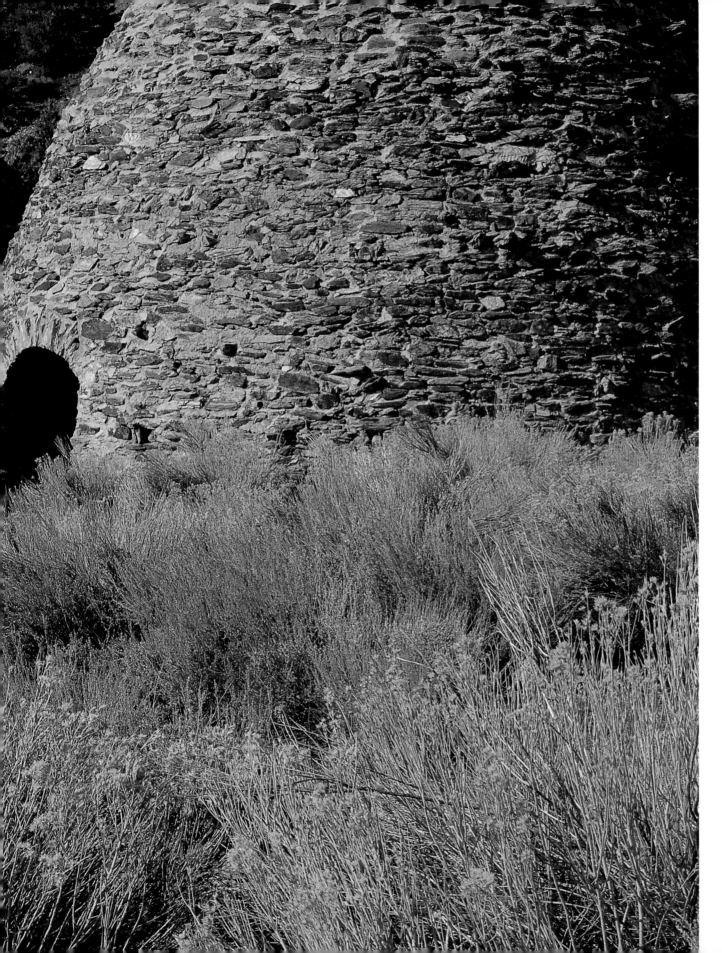

These 25-foot-high domes are kilns, built in 1877 by a nearby silver smelter to create charcoal fuel. They operated for only a year before the quality of the ore deteriorated and the mine and furnaces closed.

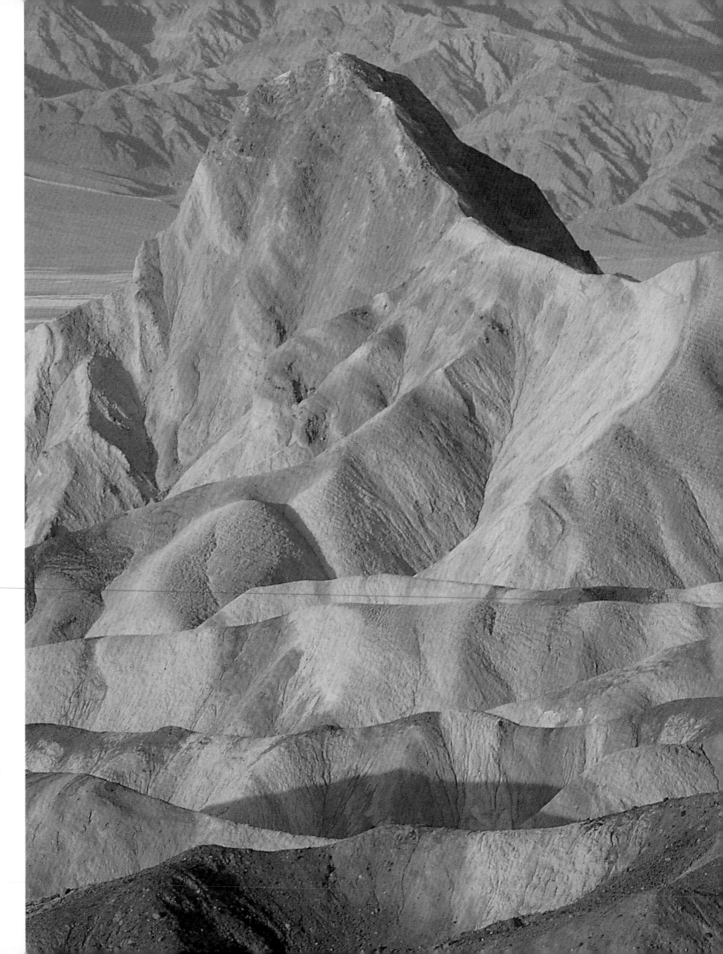

In the summer months, Death Valley temperatures soar up to 120° Fahrenheit. Despite the extreme climate and the land's stark contours, 1,000 plant species live within Death Valley National Park.

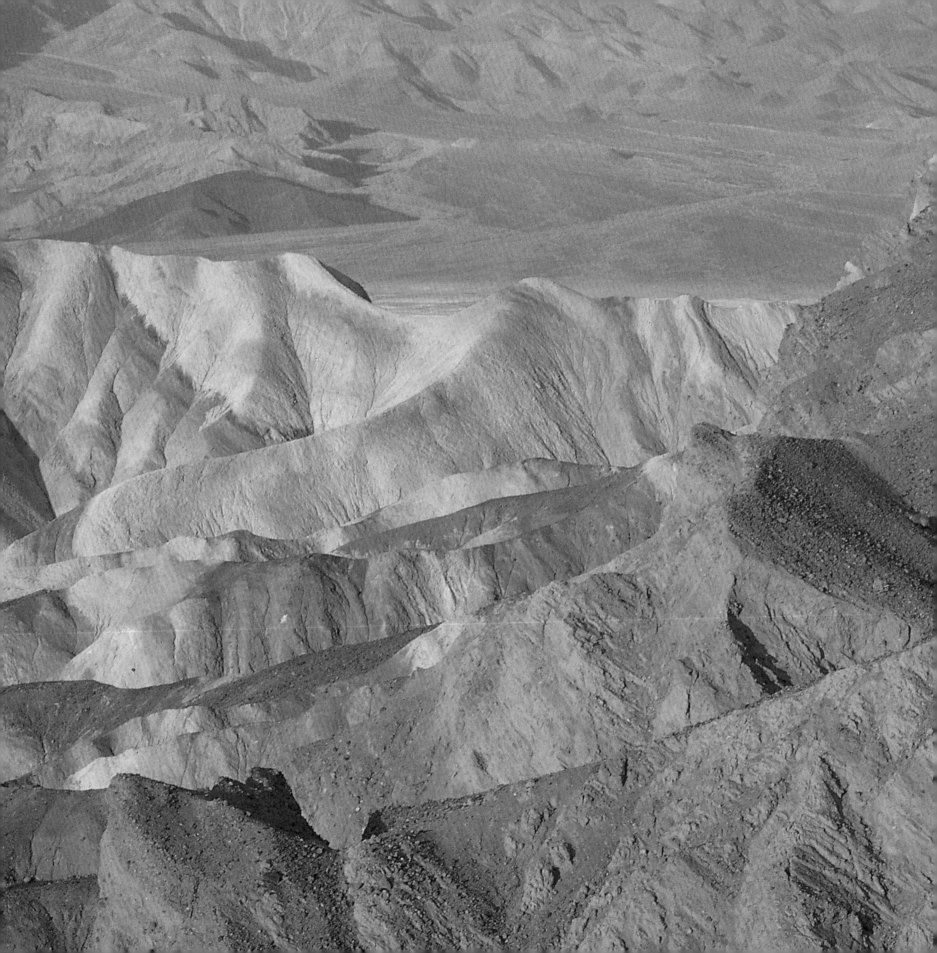

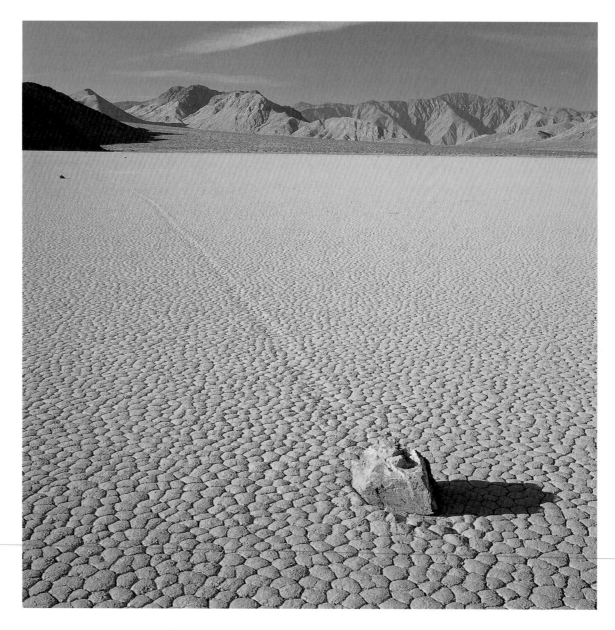

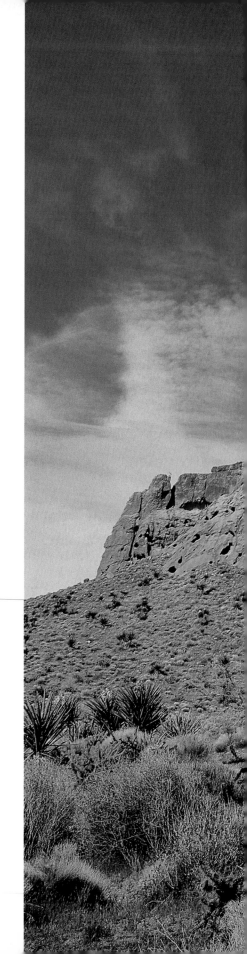

Strong winds guide rocks and pebbles across the dry mud flats known as
the devil's racetrack, leaving mysterious paths in the earth. This is just one
of the unusual sights within the 3.3-million-acre Death Valley National Park.

The Mojave National Preserve was established in
1994 to protect the desert landscape of the "lonesome
triangle" in southern California including Joshua tree
forests, sand dunes, and volcanic formations.

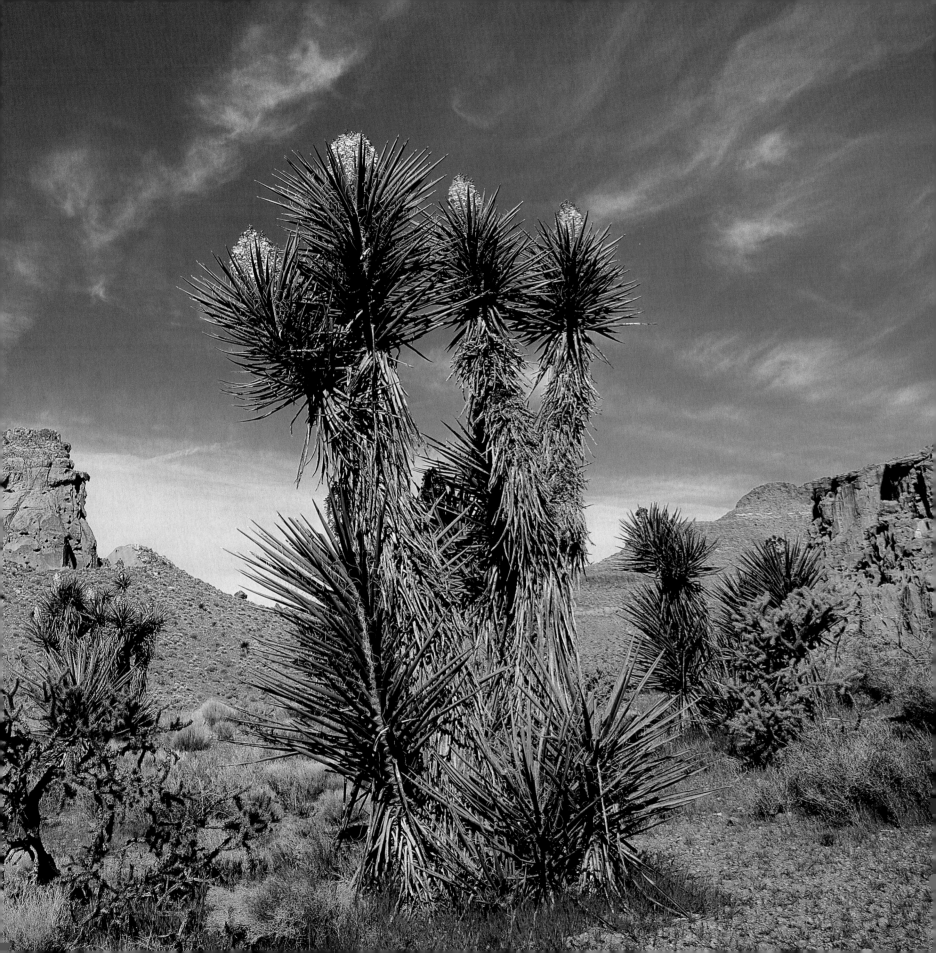

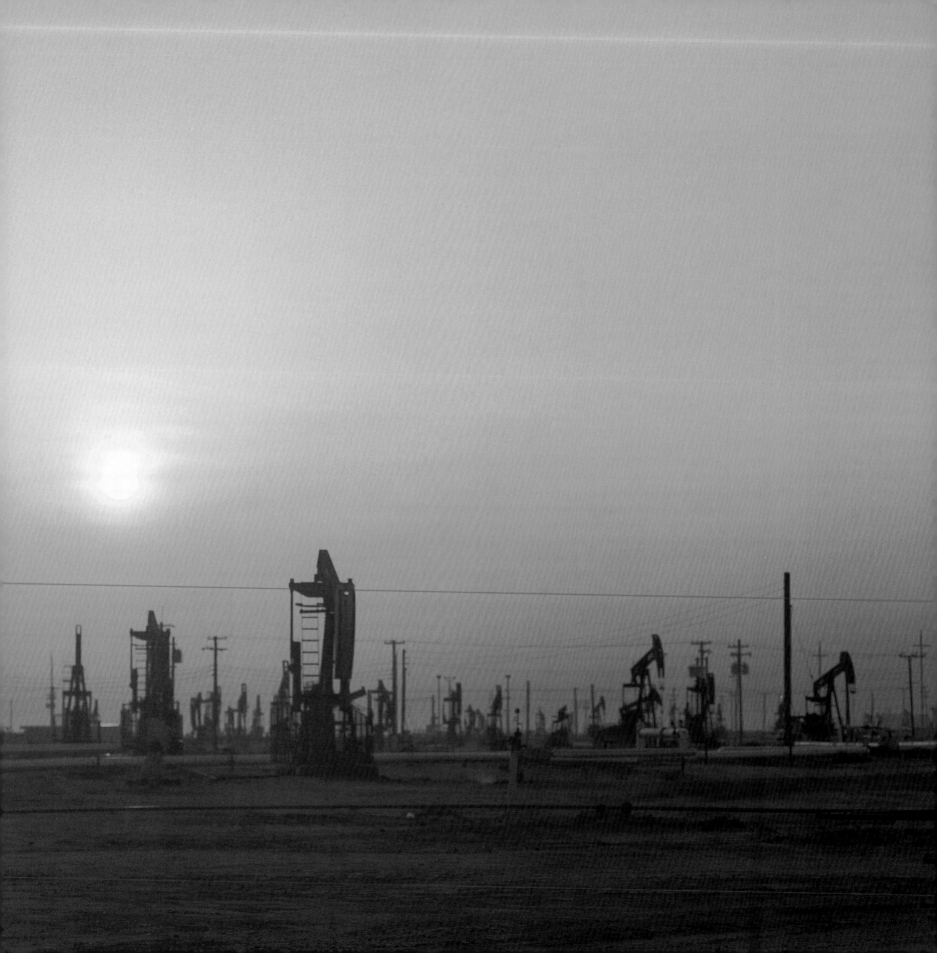

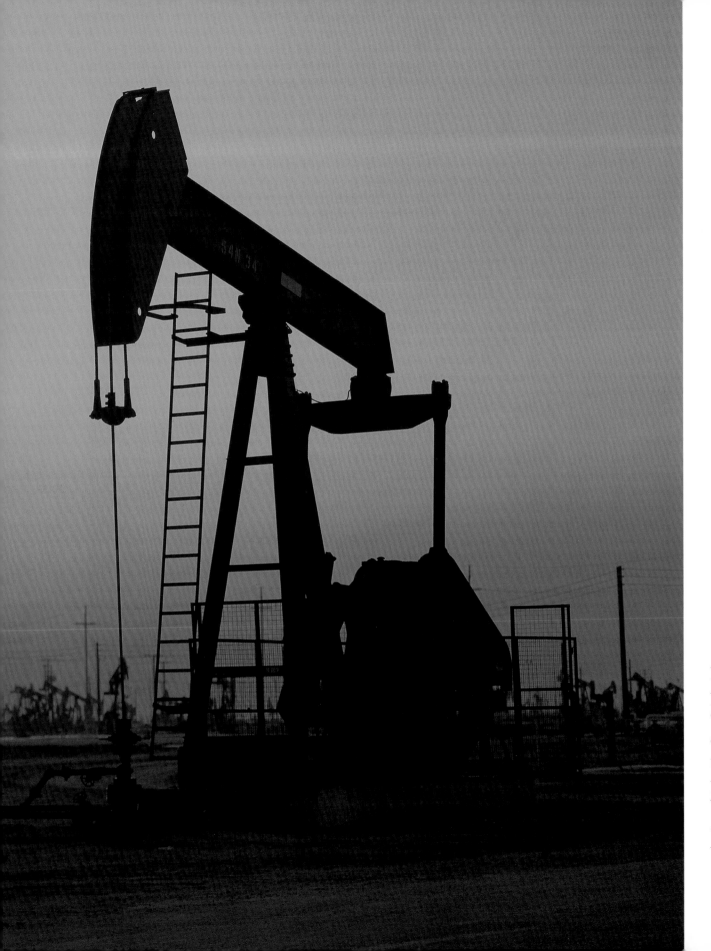

Each day, California produces about 900,000 barrels of oil, making the state the fourth-largest producer in America. There are about 45,000 oil and natural gas wells in California.

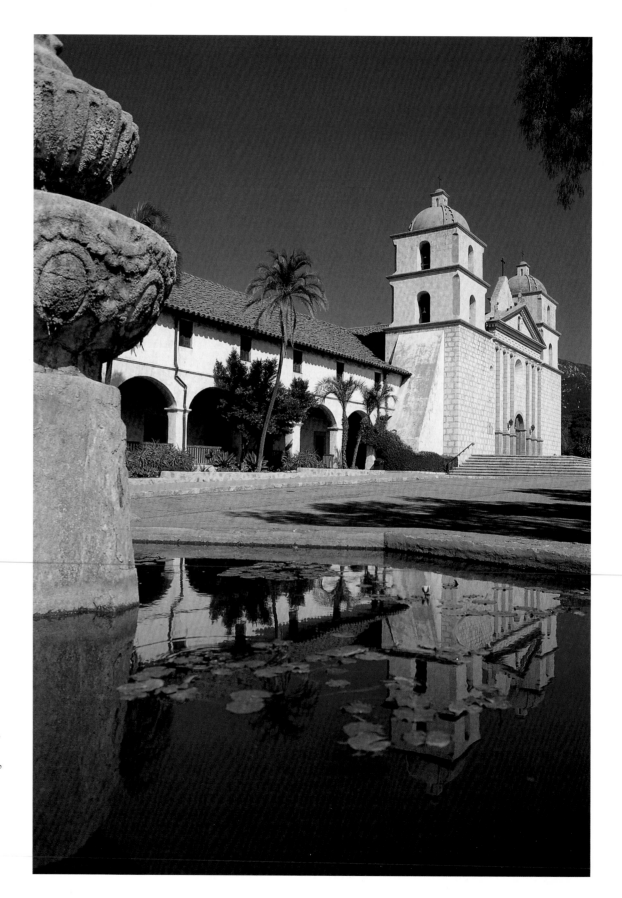

Founded on December 4, 1786, by Spanish Franciscans, the Santa Barbara Mission was the tenth in a chain of 21 built in California. With its spectacular views and twin bell towers, it is considered one of the most beautiful of the historic outposts.

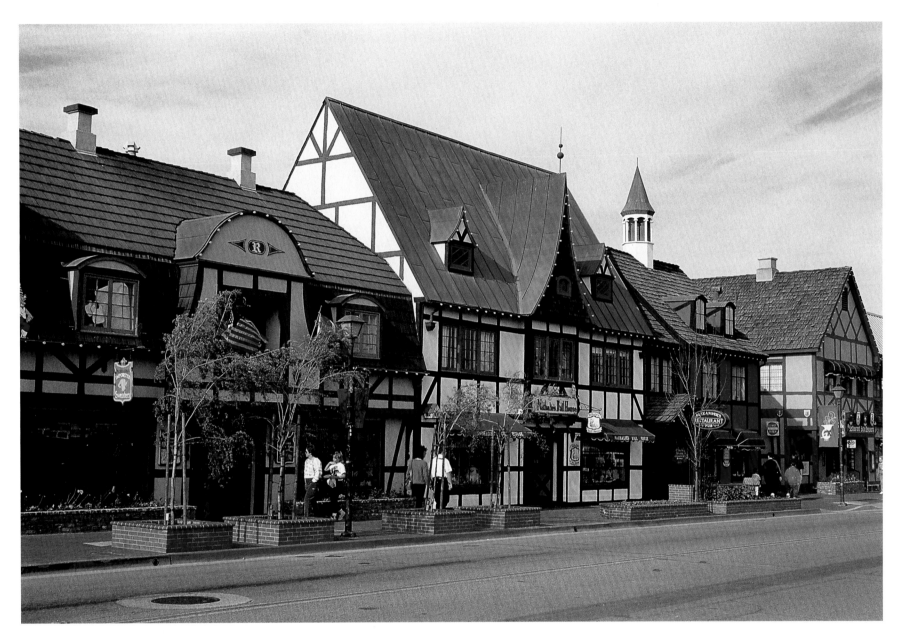

With windmills, horse-drawn carriages, traditional bakeries, and smorgasbord restaurants, visiting Solvang is like stepping onto a street in Denmark a century ago. Settled in 1911 by Danish immigrants, Solvang has transformed its heritage into a major tourist attraction.

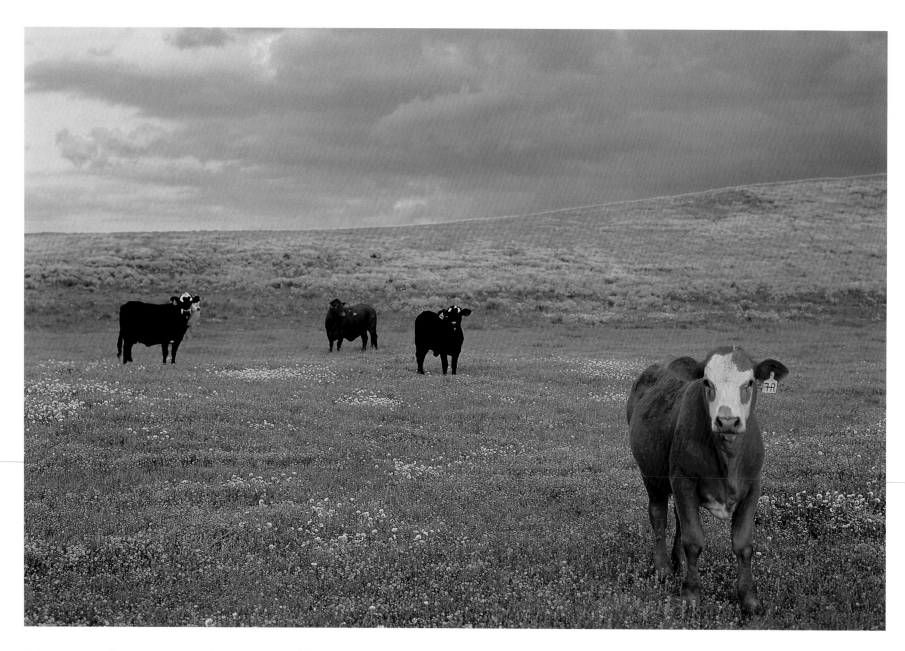

There are about 40,000 farms in California, including more than 700 in Santa Barbara County. Crops account for more than 90 percent of the profits in the county; livestock, such as cattle, makes up the rest.

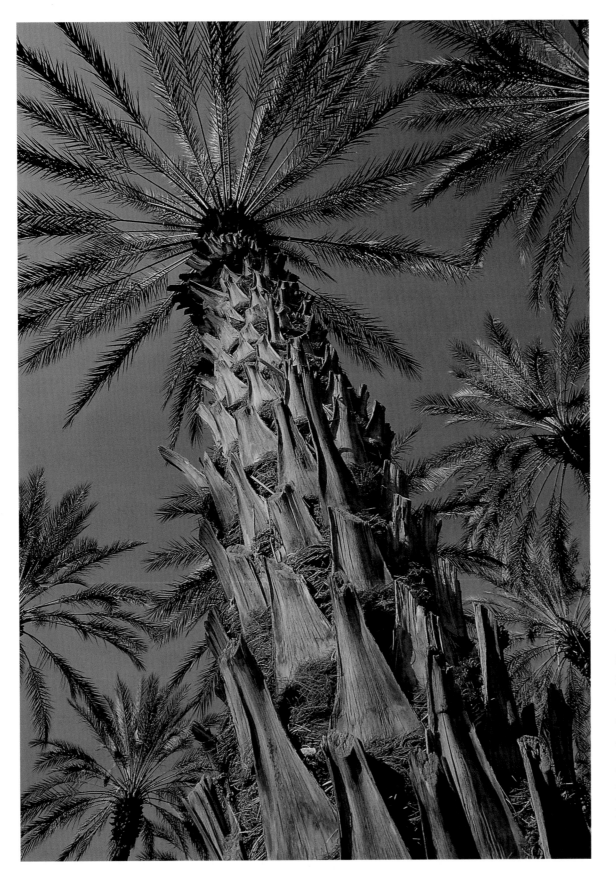

These date palms,
a symbol of sun and
relaxation for the
visitors who flock
to California each
winter, represent just
one of about 5,200
plant and tree species
in the state.

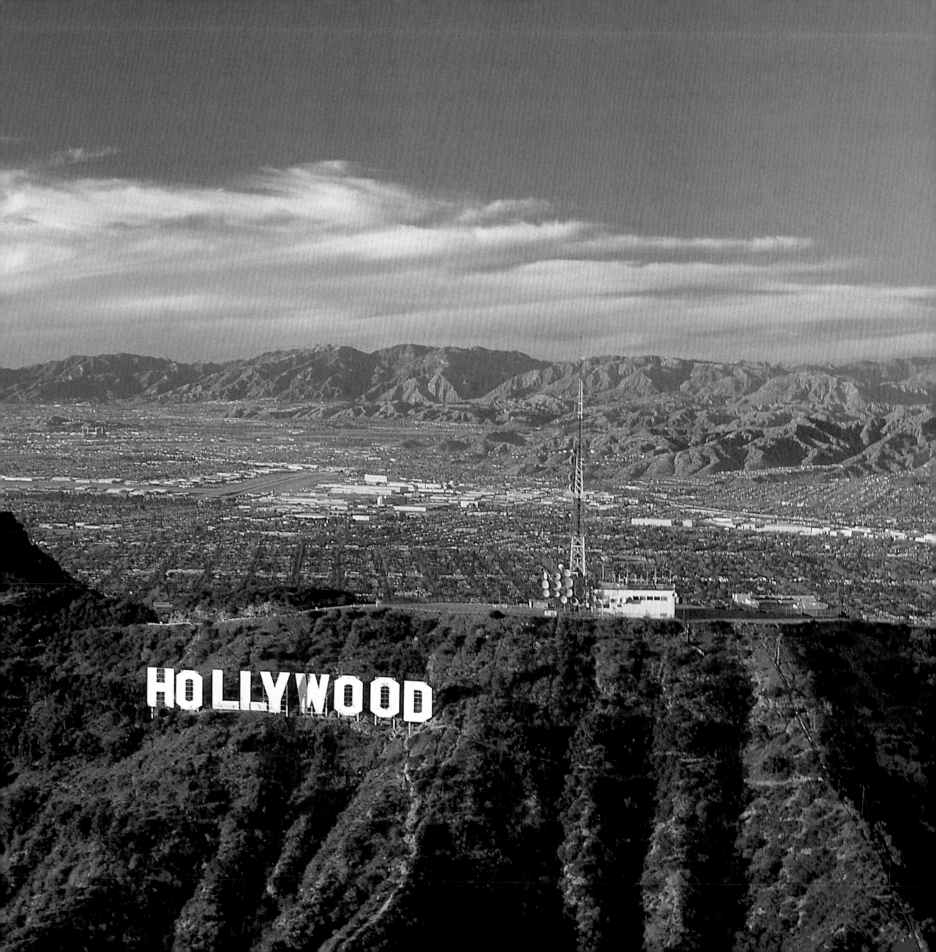

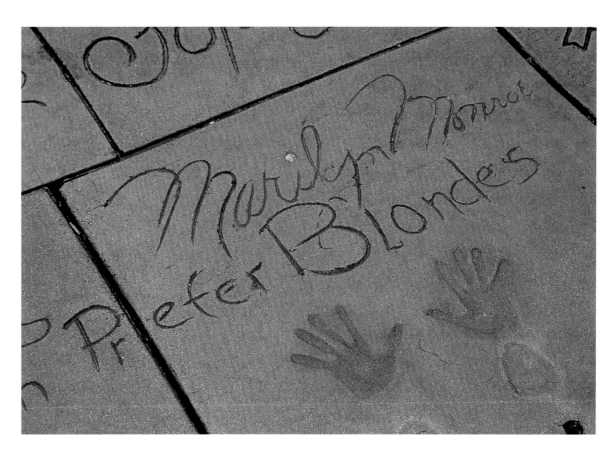

The signature of Marilyn Monroe is just one of the glimpses of stardom
that draw more than nine million visitors to Hollywood each year.

The famous Hollywood sign originally read "Hollywoodland."
It was created by land developer Harry Chandler in the 1920s
as a marketing ploy for his new residential neighborhood.
The sign was refurbished and repaired in the late 1970s.

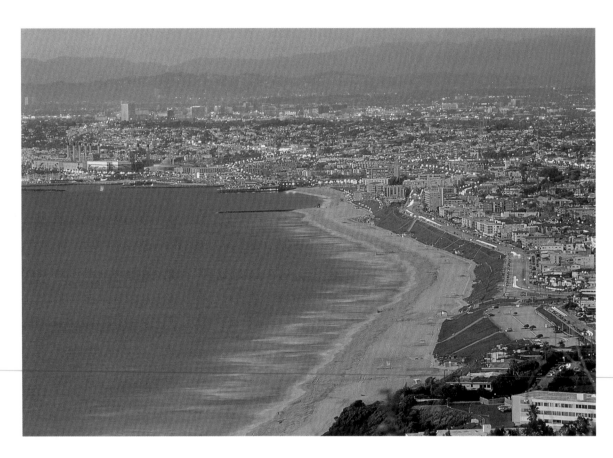

Sunseekers at Redondo Beach can splash through the waves or wander from the picturesque pier to the shops and restaurants of Riviera Village.

From movie stars and mansions to Rodeo Drive shopping and the stately city hall, Beverly Hills is California's center of wealth and luxury. The first of the area's glamorous residents were Douglas Fairbanks and Mary Pickford, who built a home here in 1920.

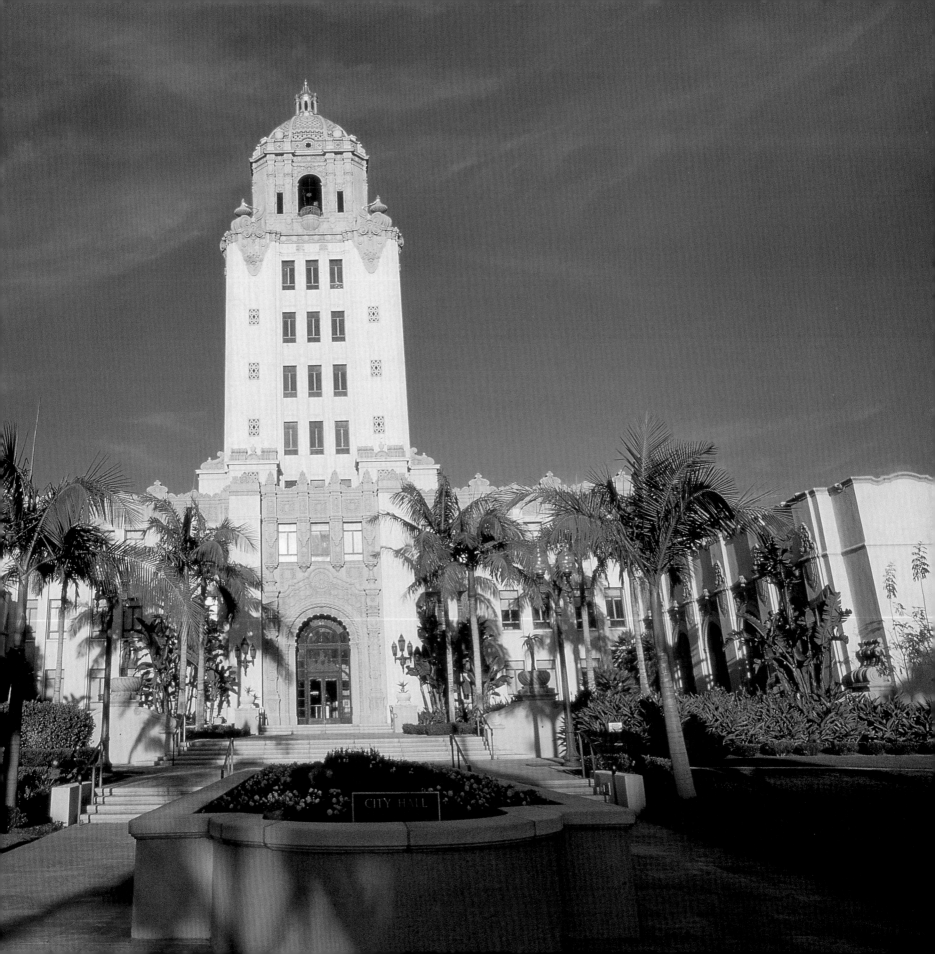

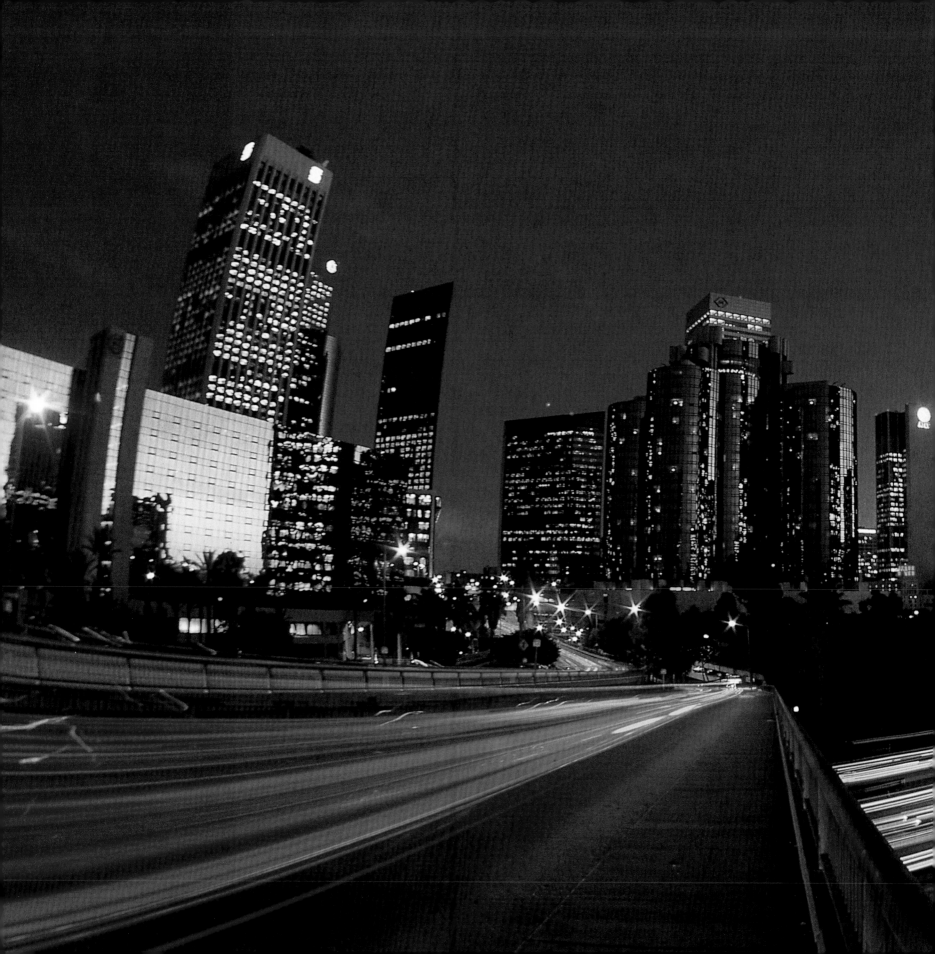

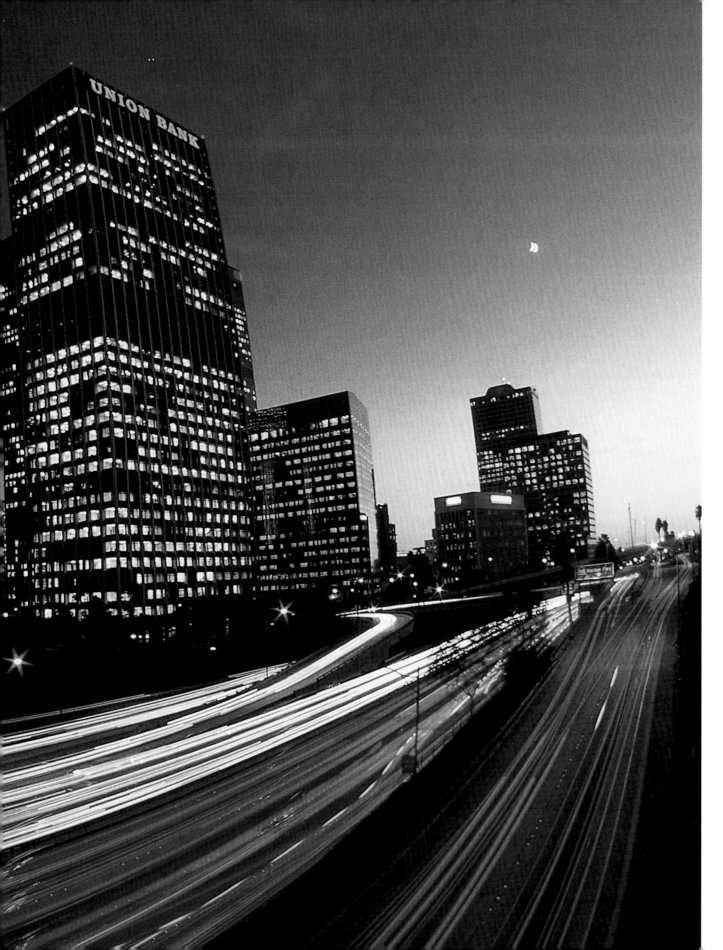

Metropolitan Los Angeles is more than twice the size of Switzerland and home to 14.5 million people. The city itself boasts more than 80 theaters and 300 museums—more than any other city in the nation.

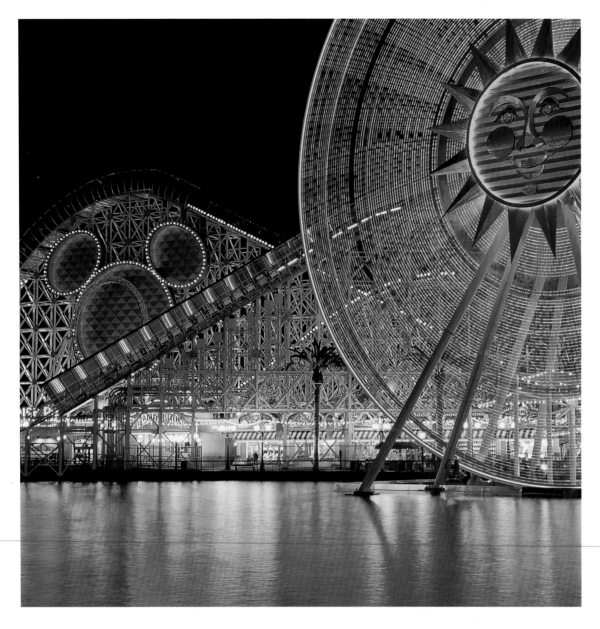

Disney's California Adventure theme park celebrates the spirit of the state with a recreation of Hollywood, a historic seaside boardwalk, amusement rides, and more. The park cost $1.4 billion to build and encompasses 55 acres.

Walt Disney promised fans that Disneyland Resort would never stop growing. The giant theme park that opened in 1955 with 18 attractions now boasts more than 60, from jungle tours to three-dimensional adventures.

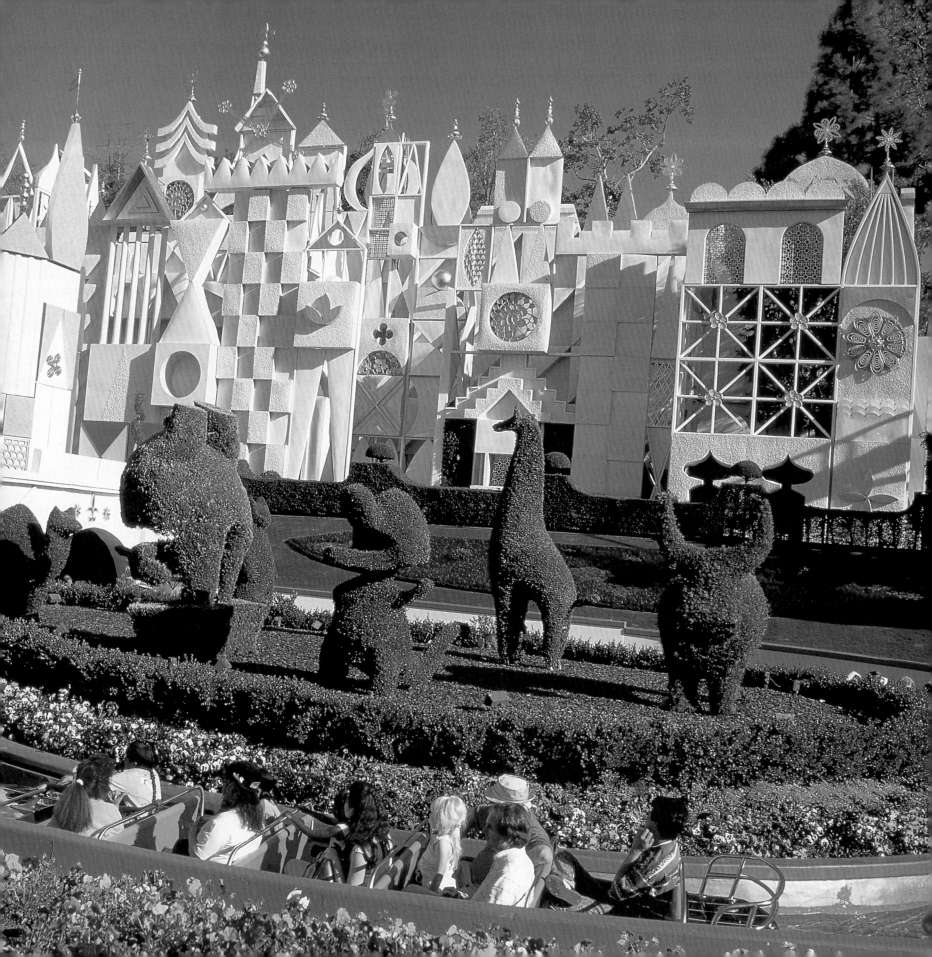

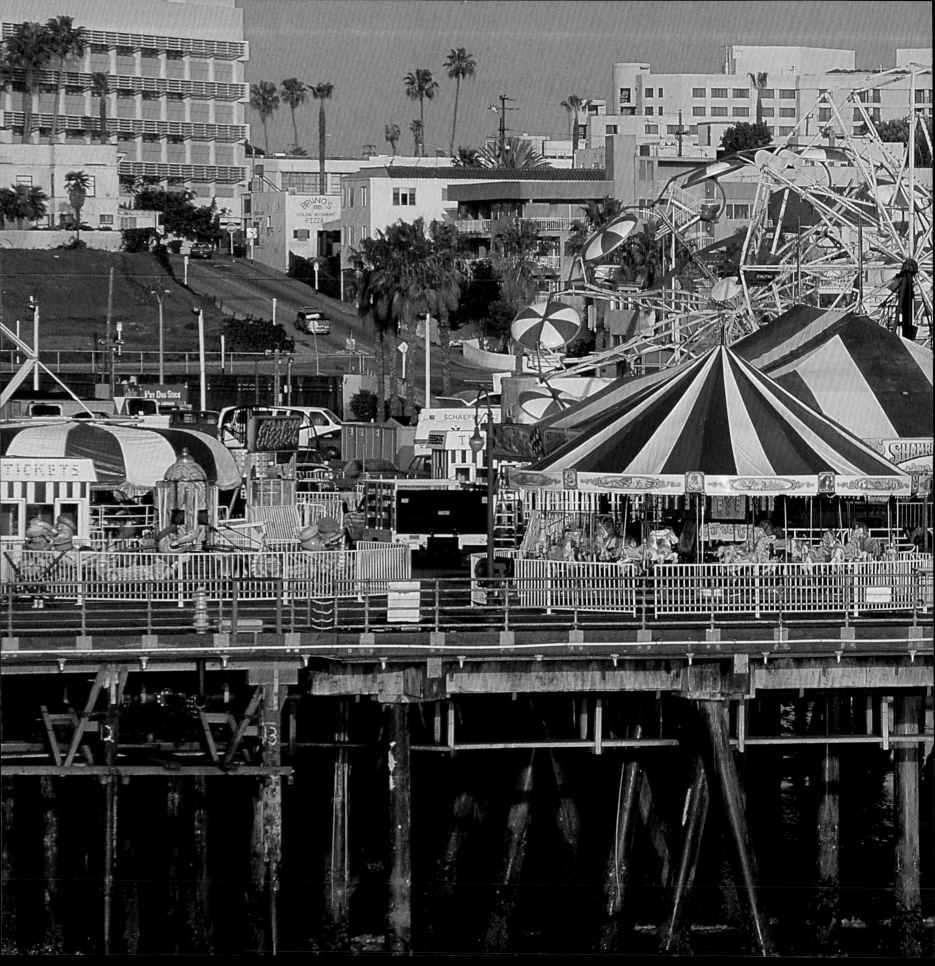

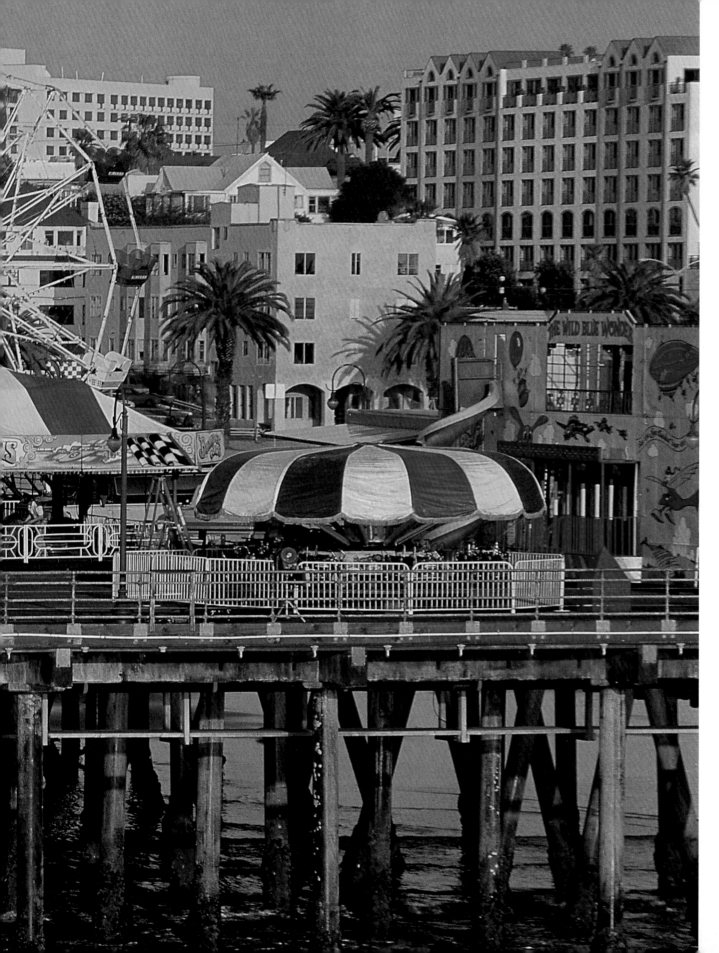

When the city of Santa Monica decided to demolish its aging and storm-damaged piers in 1955, residents leapt to their rescue. Today the Hippodrome and its carousel are part of a National Historic Landmark, and more than 10,000 people gather for concerts here on summer evenings.

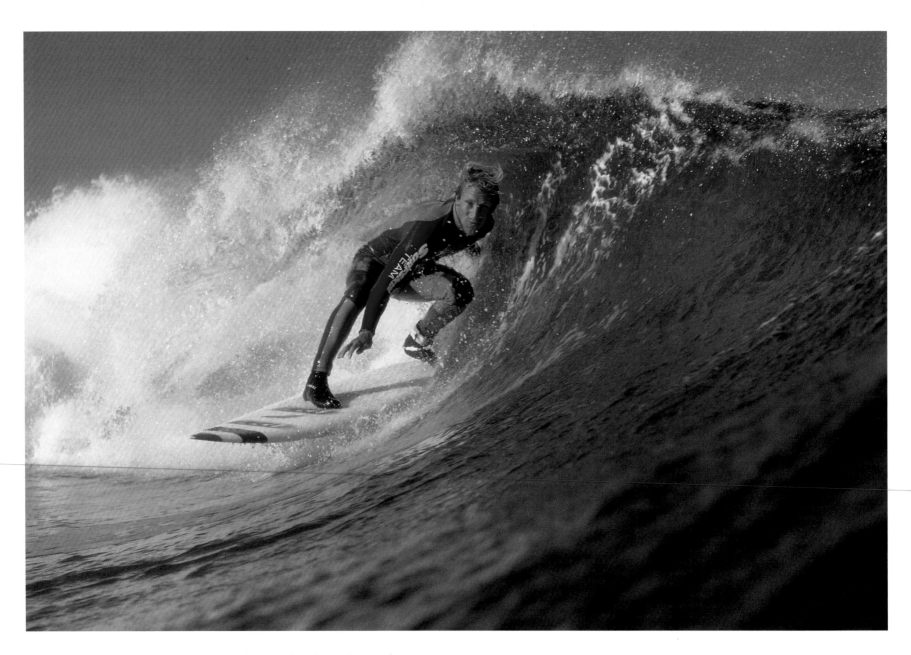

Surfers ride the wild waves along the beaches of Orange County.
International enthusiasts test their mettle in a number of surfing
competitions here each summer.

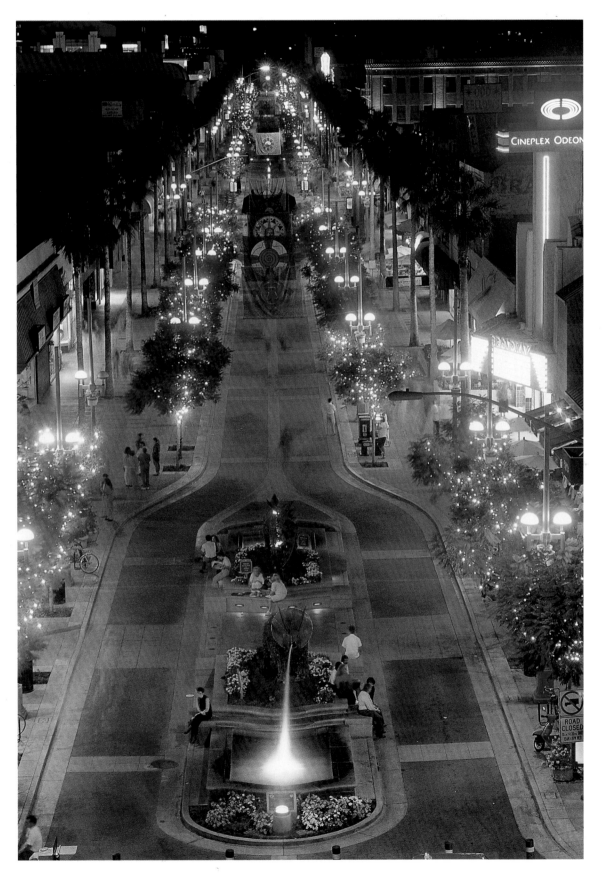

Antiques, jewelry, footwear, and furniture—pedestrians find every store imaginable as they wander Third Street Promenade, a shopping mecca just a few blocks from the Santa Monica Pier.

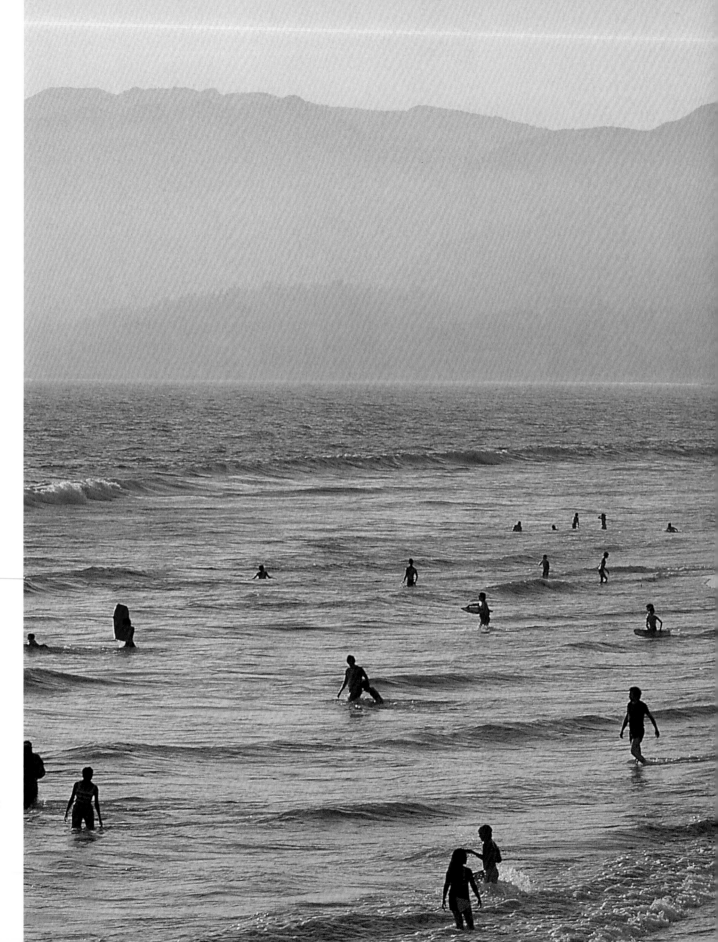

A sun-lover's heaven, Santa Monica State Beach offers miles of white sand for sunbathing, beach volleyball for sports enthusiasts, and a promenade for in-line skaters, cyclists, and walkers.

72

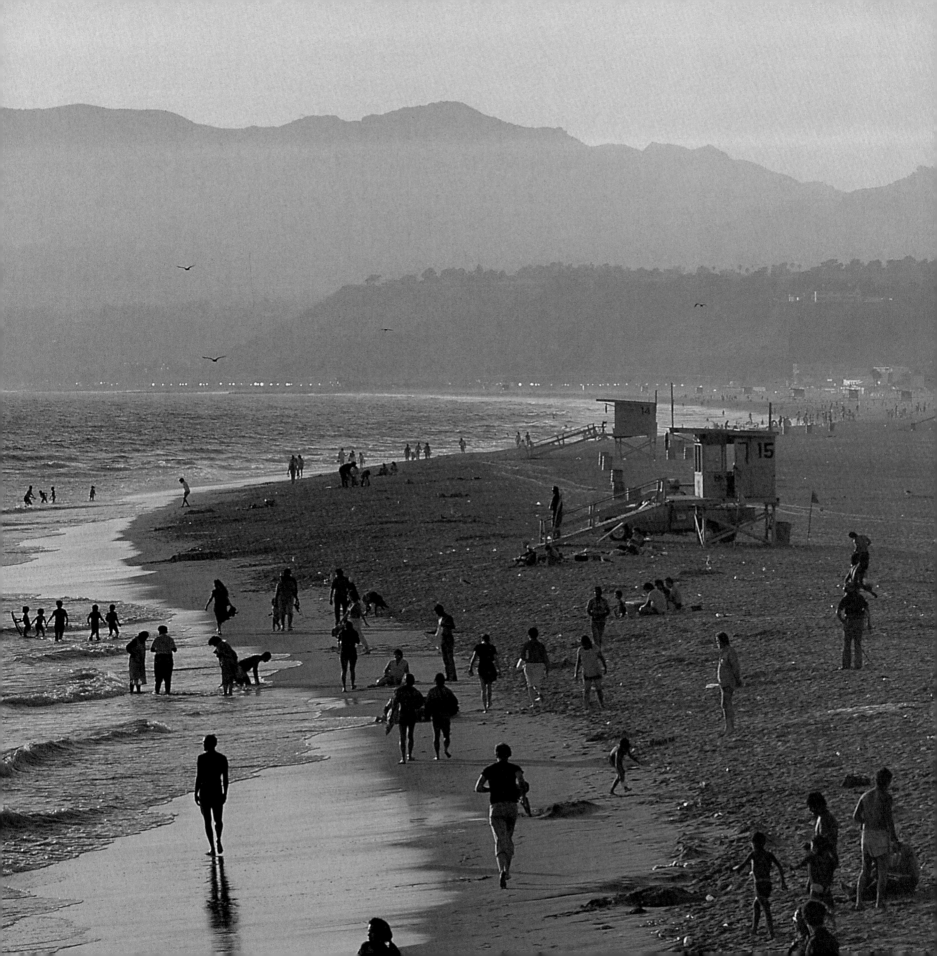

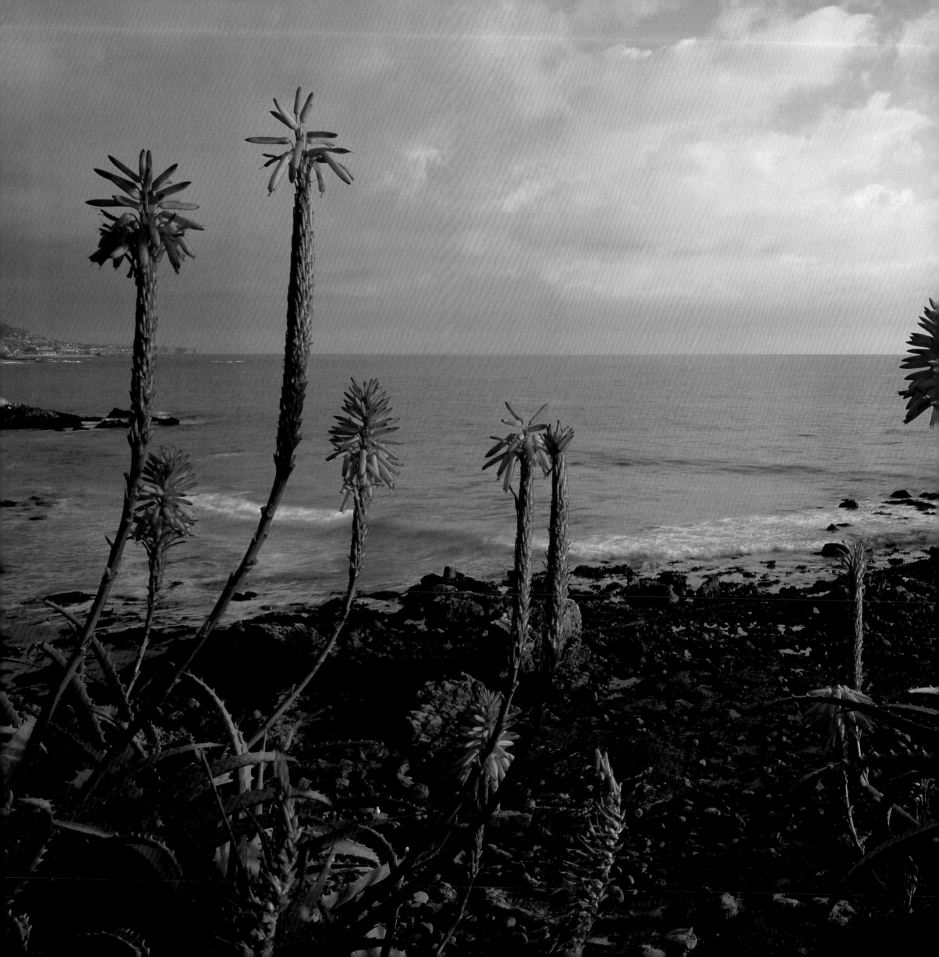

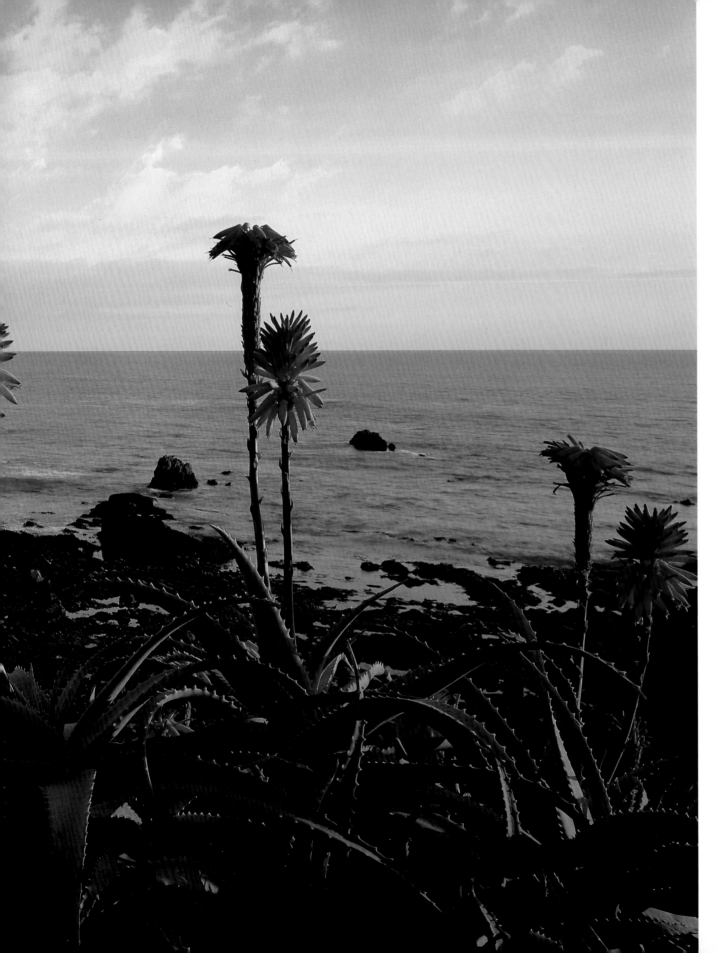

Aloe blooms on the rocks above Laguna Beach, a combination of artists' retreat and resort haven. Canyons and cliffs surrounding the beach rise more than 1,000 feet above the ocean swells.

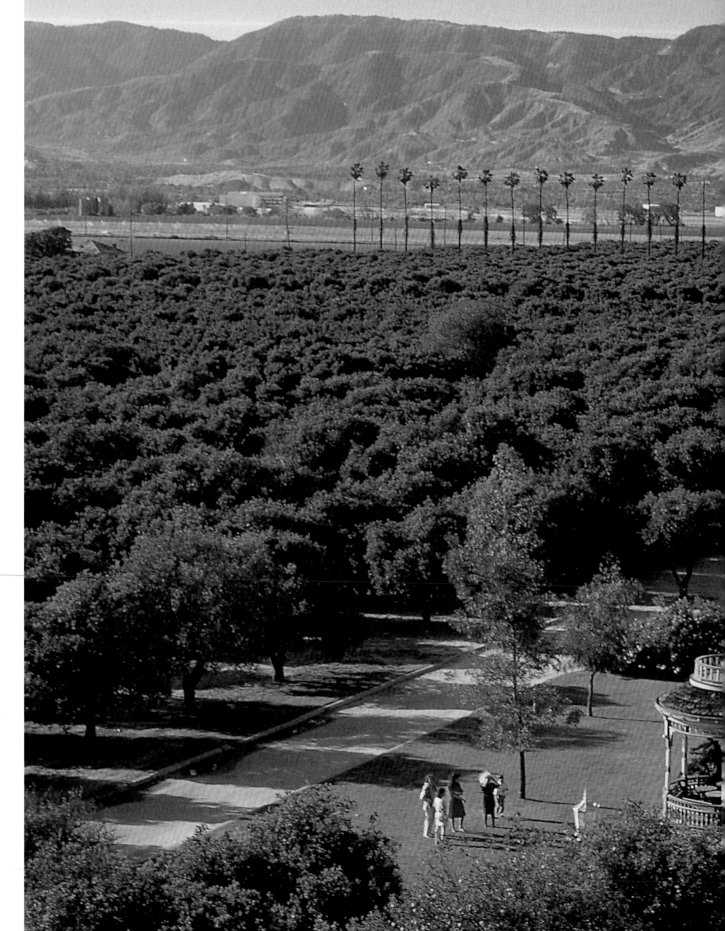

Oranges such as those grown in these Redlands groves are California's fifth most important product, after cotton, almonds, wine, and table grapes. Orange exports contribute $307 million to the state economy each year.

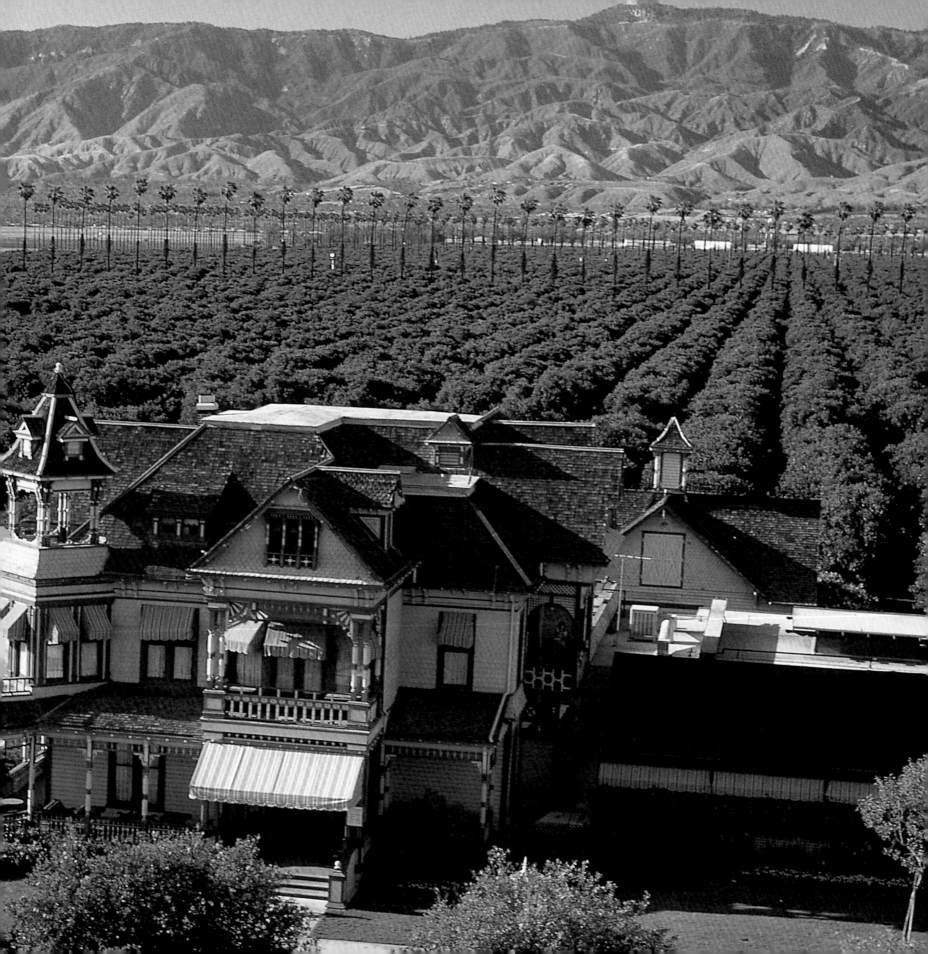

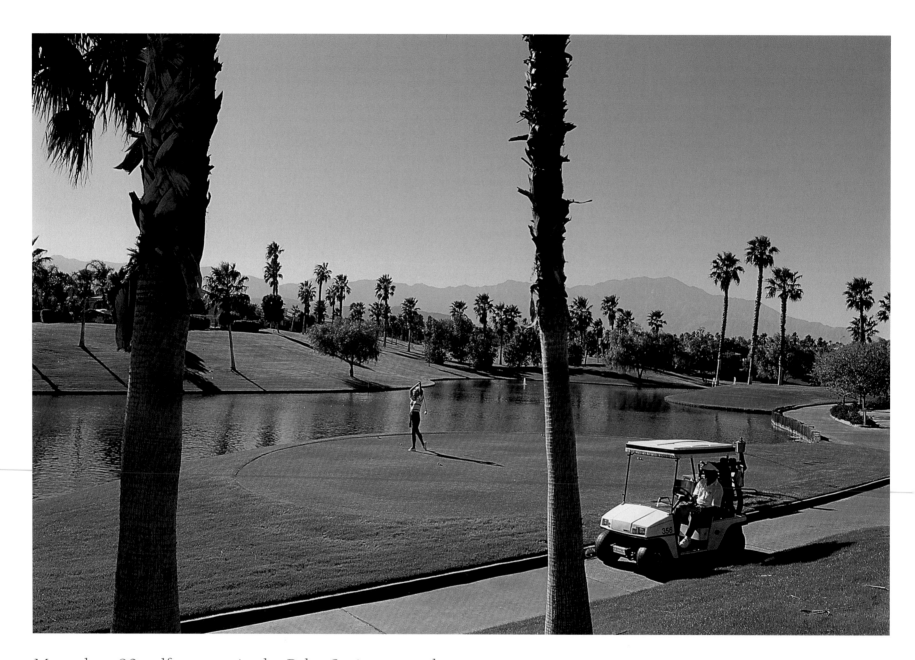

More than 90 golf courses in the Palm Springs area draw enthusiasts from around the world. Many host internationally televised competitions and PGA events.

Palm Springs has served as a retreat for Hollywood celebrities since the 1930s. Today, visitors can lounge in lavish resort hotels, enjoying some of the area's 30,000 swimming pools, or camp in the surrounding parks.

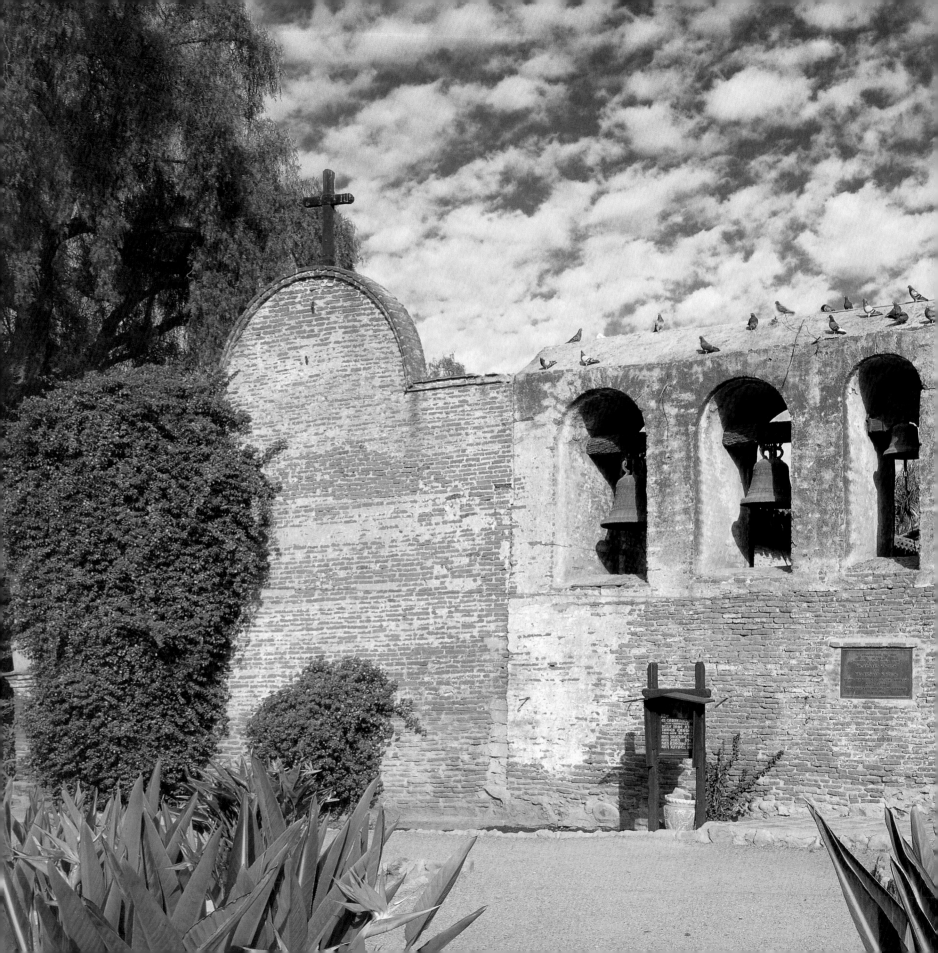

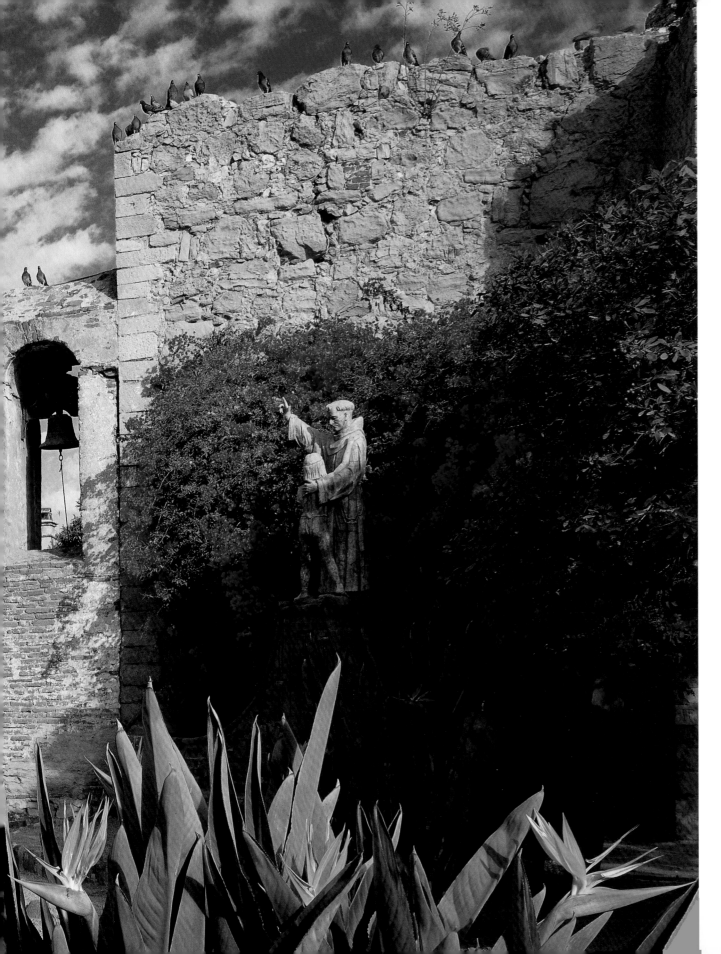

Some of the oldest buildings in the state whisk visitors to the 18th century at Mission San Juan Capistrano, founded by Roman Catholic priest Father Junipero Serra in 1776. A $20-million restoration campaign has helped protect some of the mission sights.

81

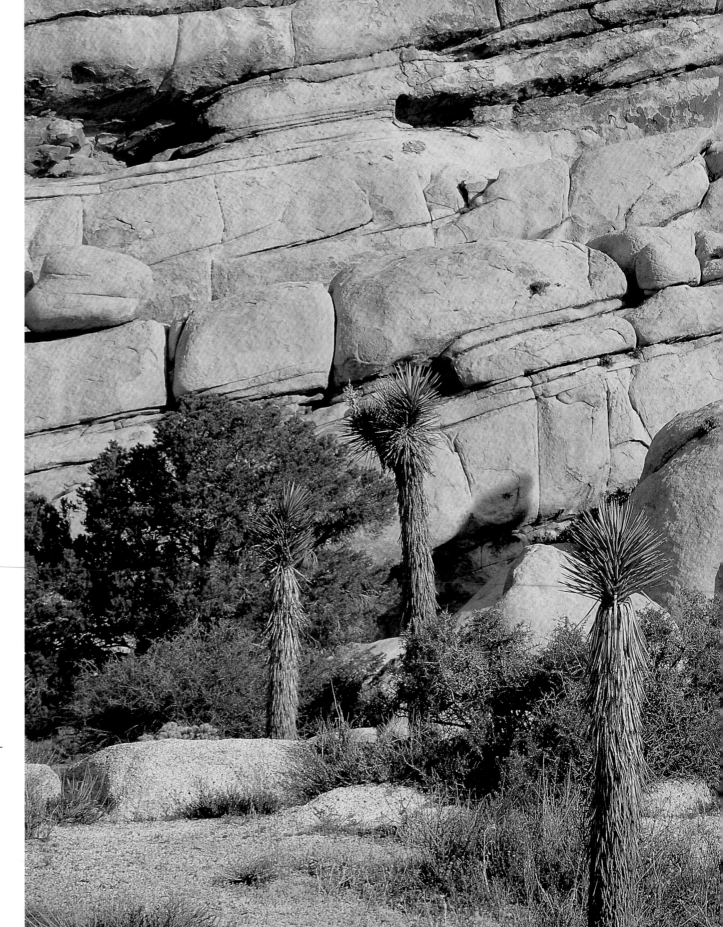

The 794,000 acres of Joshua Tree National Park extend from the high Mojave Desert—habitat of the Joshua tree—to the lower Colorado Desert to the east.

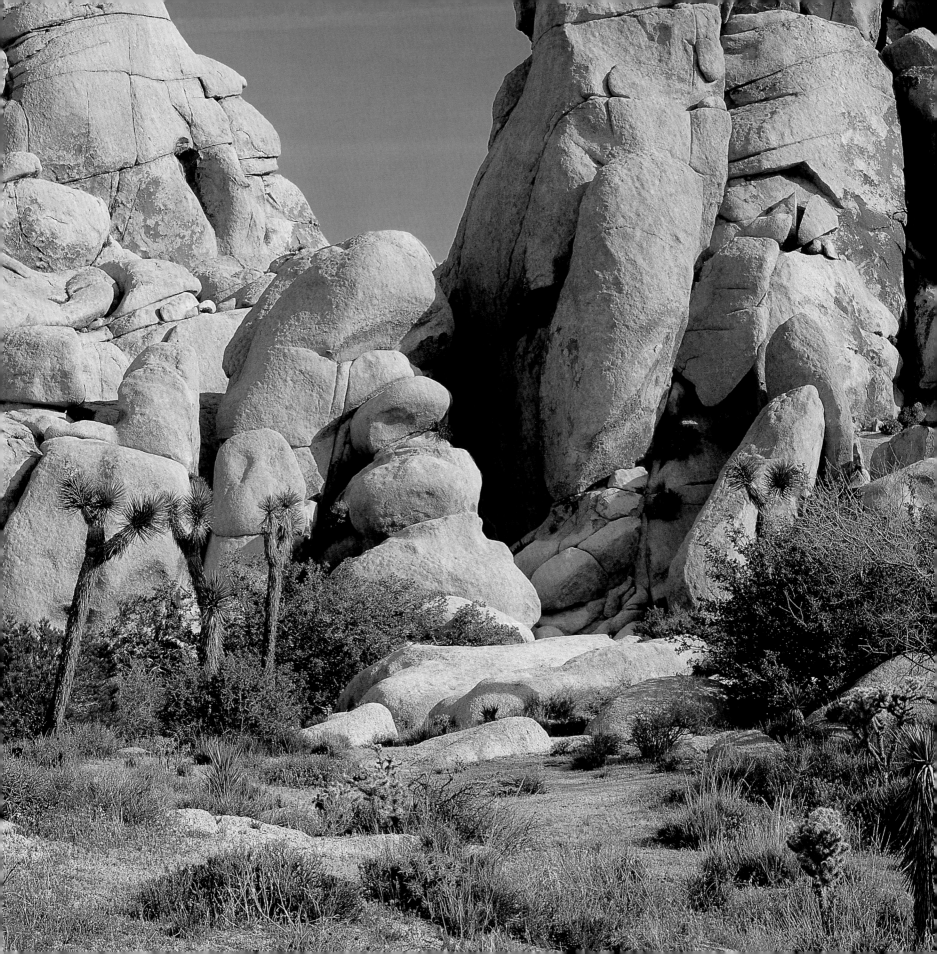

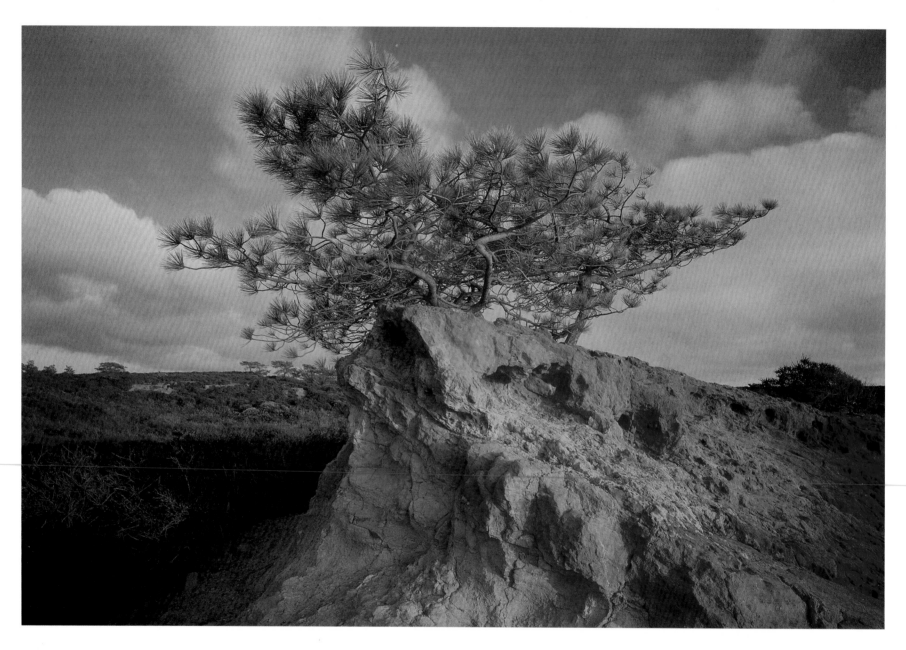

Torrey pines—the rarest pine trees in the world—grow only on Santa Rosa Island and in the 1,750-acre Torrey Pines State Reserve and Beach, created for their protection. About 6,000 grow within the park.

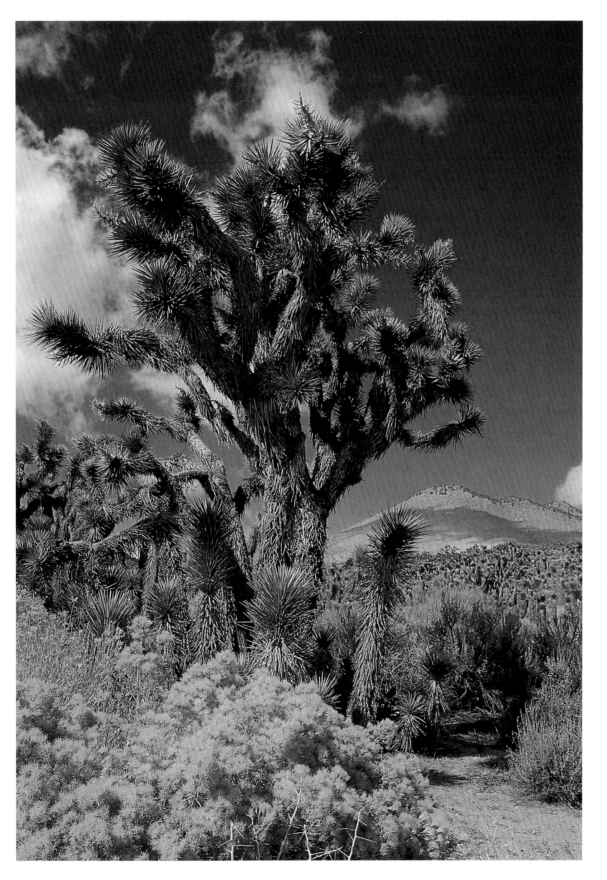

Joshua trees are giant members of the yucca family. Mormon settlers traveling west to the California coast in the 1850s saw the shapes of the trees as representative of the prophet Joshua, raising his arms to heaven and guiding them onward.

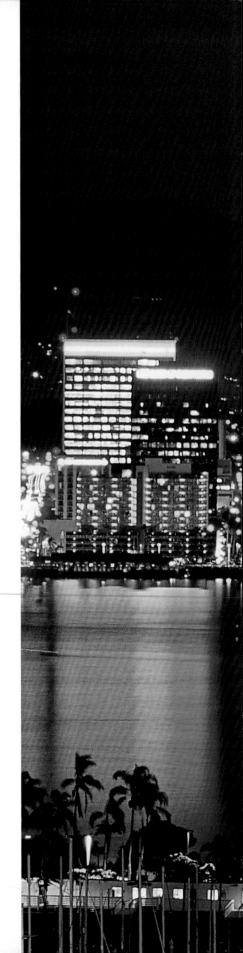

San Diego enjoys a balmy average daily temperature of 70.5° Fahrenheit and receives only 10 inches of rain per year. It's no surprise that it has become one of the largest cities in the state.

Explorer Juan Rodriguez Cabrillo named this area San Miguel when he sailed here in 1542. Half a century later, explorer Sebastian Vizcaino arrived and renamed the bay San Diego.

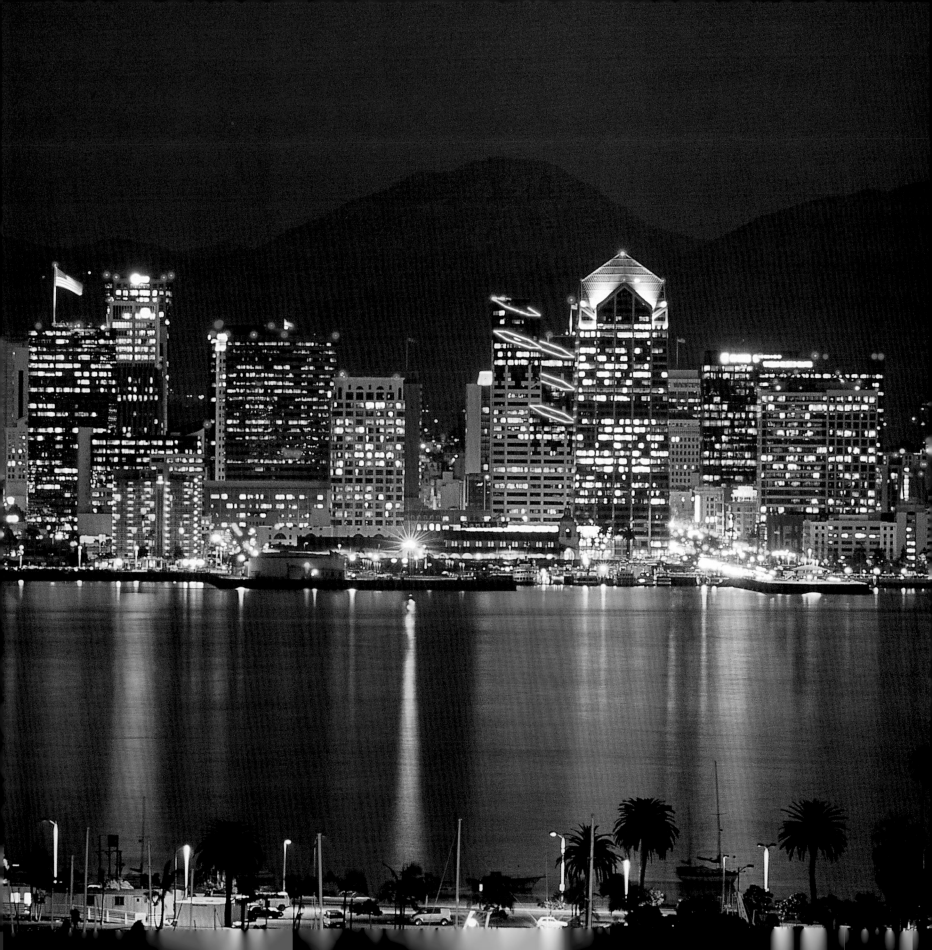

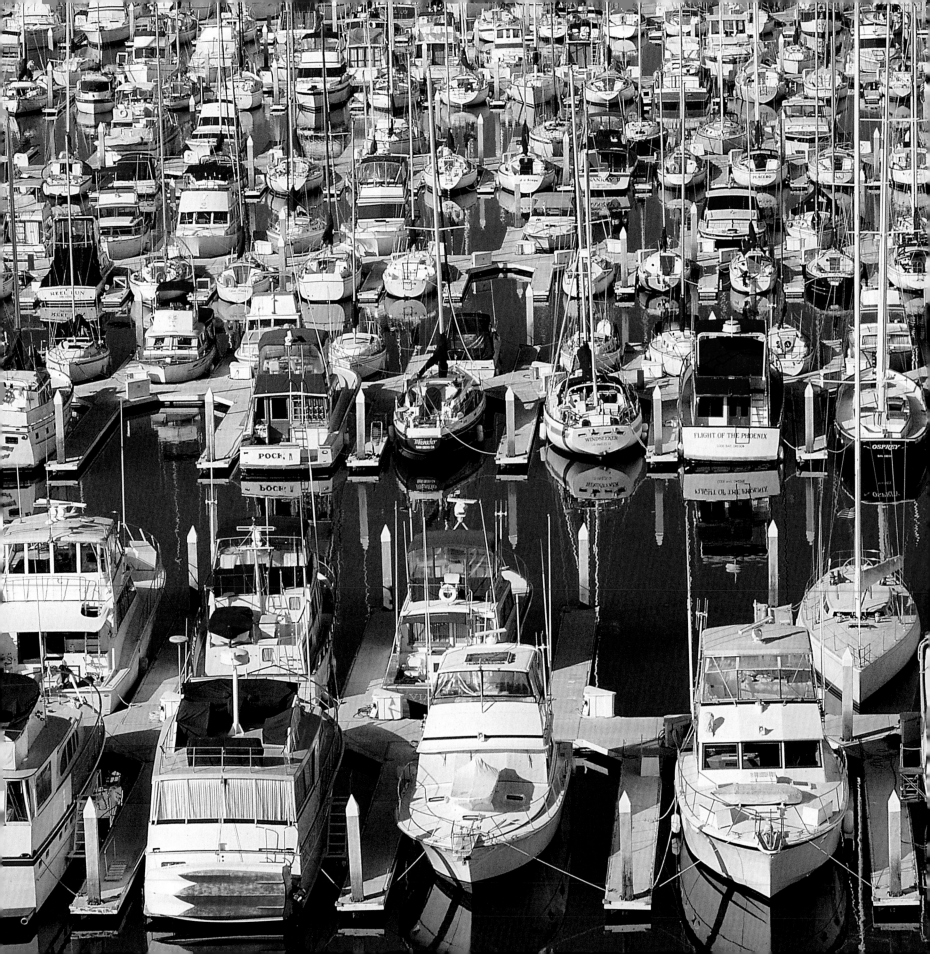

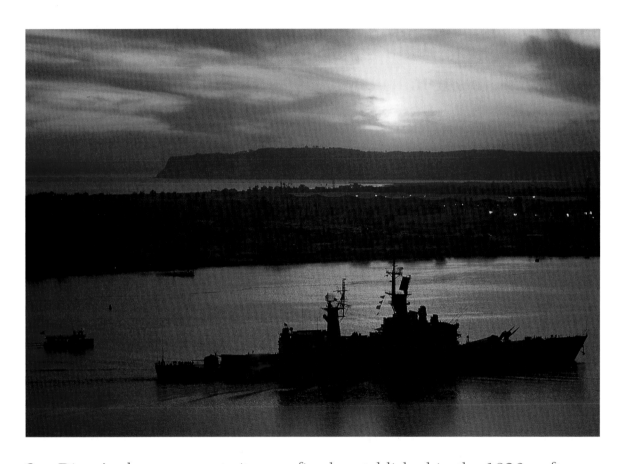

San Diego's place as a port city was firmly established in the 1920s, after a naval base was built in the bay.

Vessels of all sizes crowd San Diego's harbor. Along with navy and commercial ships, the city boasts the largest sport-fishing fleet in the world.

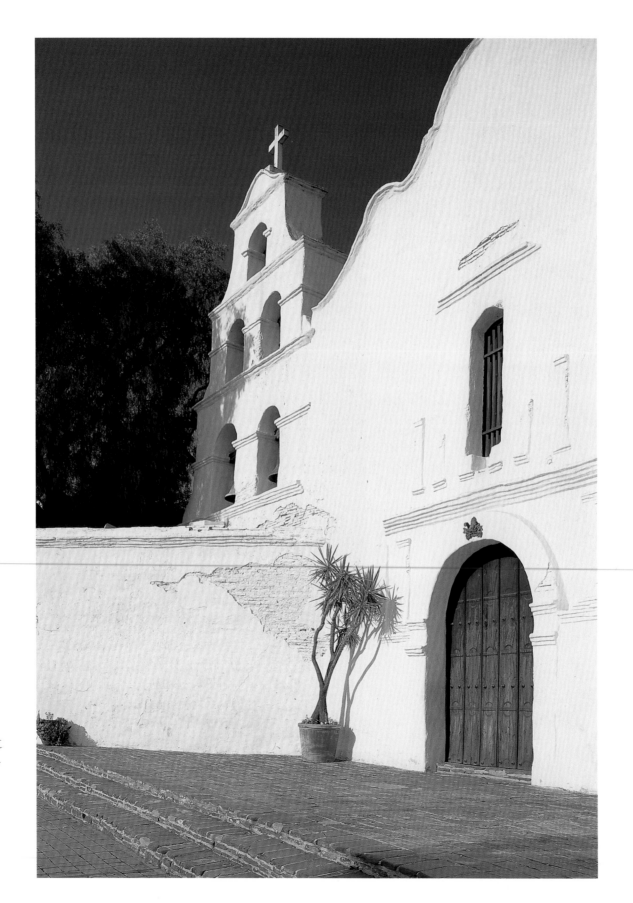

Led by Junipero Serra, Spanish missionaries built Mission San Diego de Alcala in 1769. This is just one of the areas in the city where the architectural influence of the region's first settlers is obvious.

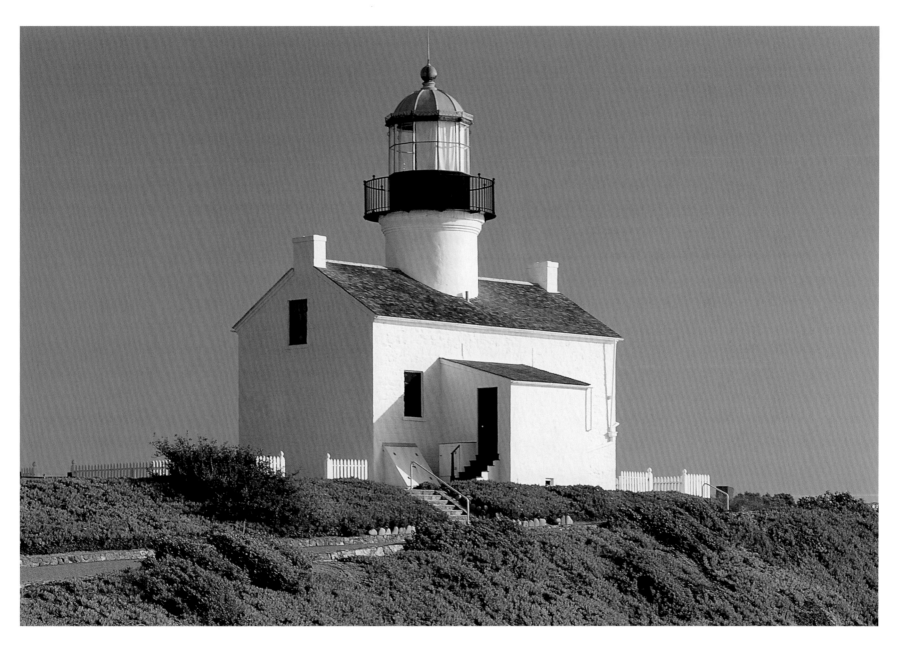

The Old Point Loma Lighthouse guided vessels into San Diego Bay for 36 years. Because fog often obscured the beacon, a new lighthouse was built closer to the shore in 1891. The old lighthouse was restored by the National Park Service and is now open to the public.

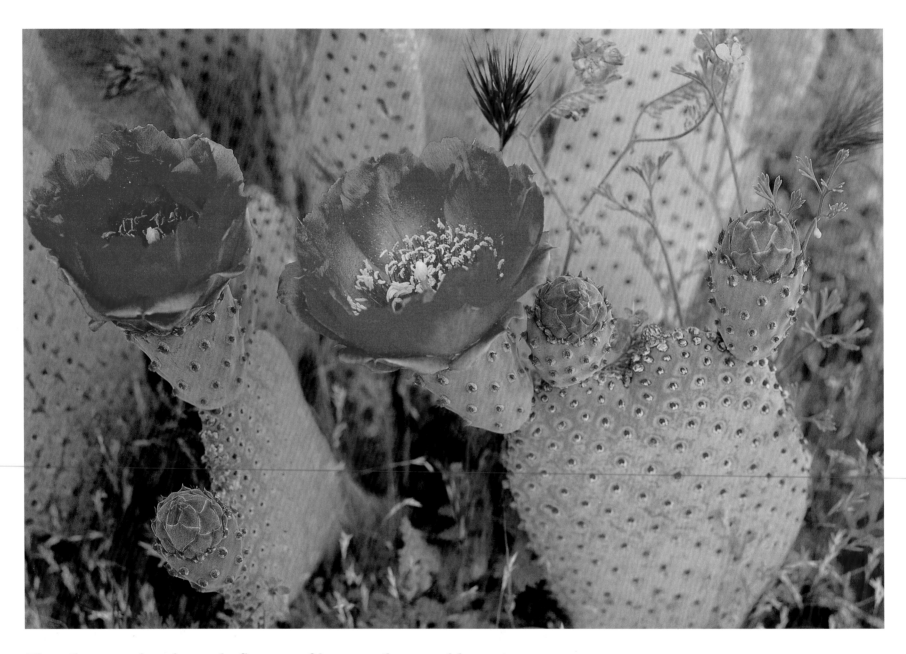

The vibrant red and purple flowers of beavertail cactus bloom in
early summer in the Mojave and Sonoran deserts, creating splashes
of color on dry, rocky slopes.

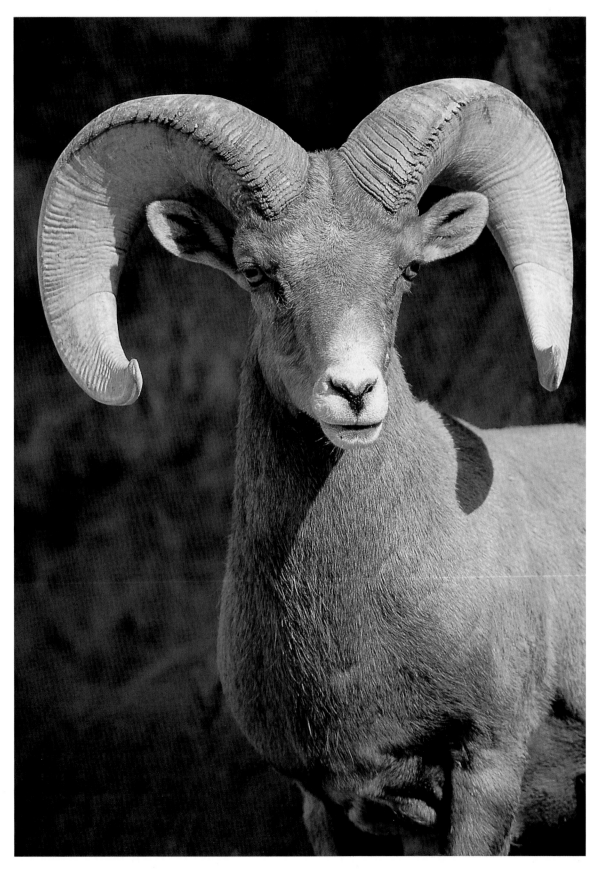

Hunting and loss of habitat has decimated the bighorn sheep population in California. Parks such as Mojave National Preserve and Anza-Borrego Desert State Park are contributing to an effort to save the animal.

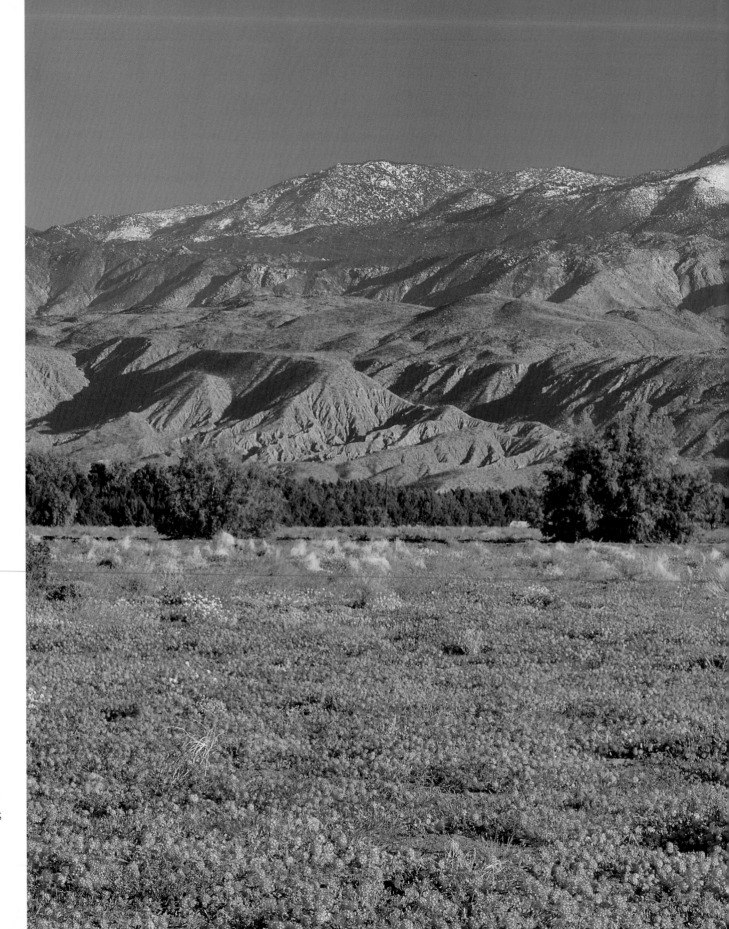

In southern California, Anza-Borrego Desert State Park is home to a wealth of wildflowers, from yellow chinchweed and cholla to barrel and beavertail cactus. Each year, the park predicts the best viewing season, helping flower enthusiasts plan their trips.

94

Photo Credits

Ron Watts/First Light i, iii, 68–69, 87

Bill Ross/First Light 6–7, 28–29, 37, 40–41, 60, 64–65, 76–77, 88

Terry Donnelly 8, 11, 34–35, 38–39, 46, 47, 48–49, 52, 53, 58, 82–83, 92, 94–95

Mary Liz Austin 9

D.C. Lowe/First Light 10, 15, 19

Jürgen Vogt 12, 14, 18, 25, 44–45, 50–51, 54–55, 85

Inga Spence/First Light 13

Tom Till 16–17, 24, 30, 31, 42, 43, 74–75, 80–81, 84

Mark E. Gibson/Dembinsky Photo Assoc 20

Greg Vaughn/First Light 21, 57

Jeff Greenberg/Unicorn Stock Photos 22

Mark E. Gibson/Unicorn Stock Photos 23

D. Boone/First Light 26–27

Jeff Foott/First Light 32–33

Wayne Lynch 36, 59, 93

D & J Heaton/First Light 56

Robert Landau/First Light 61, 63, 71

Lawrence Manning/First Light 62

Richard Cummins/Folio, Inc. 66

Jim Zuckerman/First Light 67

Guy Motil/First Light 70

Craig Aurness/First Light 72–73, 79

Nik Wheeler/First Light 78

Brian Parker/First Light 86, 89

David L. Brown/First Light 90, 91